Urban Tomographies

Martin H. Krieger

PENN

UNIVERSITY OF PENNSYLVANIA PRESS

PHILADELPHIA

Published by
University of Pennsylvania Press
Philadelphia, Pennsylvania 19104-4112
www.upenn.edu/pennpress

Printed in the United States of America on acid-free paper

10 9 8 7 6 5 4 3 2 1

Library of Congress Cataloging-in-Publication Data
Krieger, Martin H.
 Urban tomographies / Martin H. Krieger.
 p. cm. — (The city in the twenty-first century)
 Includes bibliographical references and index.
 ISBN 978-0-8122-4304-8 (hardcover : alk. paper)
 1. Sociology, Urban—France—Paris. 2. Sociology, Urban—California—Los Angeles. 3. City and
town life—France—Paris. 4. City and town life—California—Los Angeles. I. Title. II. Series: City in
the twenty-first century book series.
HT151.K75 2011
307.760944'361—dc22 2010034425

For Sophie, Joshua, and David

Contents

Illustrations

Urban Tomographies

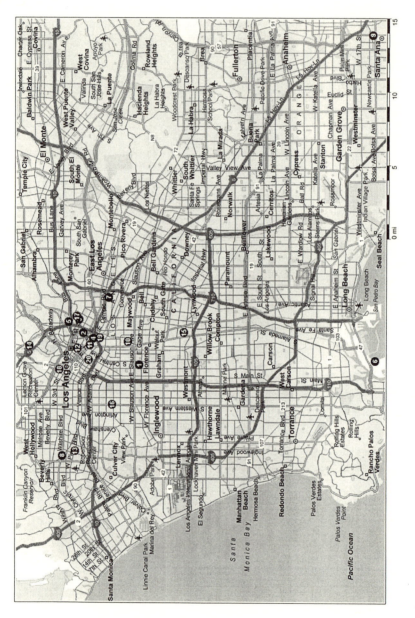
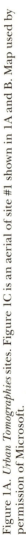

Figure 1A. *Urban Tomographies* sites. Figure 1C is an aerial of site #1 shown in 1A and B. Map used by permission of Microsoft.

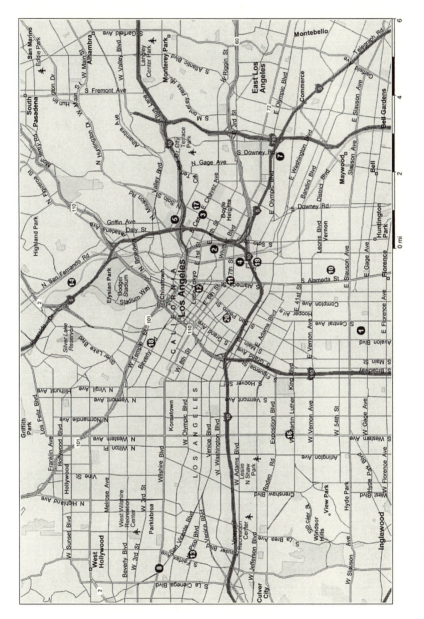

Figure 1B. *Urban Tomographies* sites (detail). Map used by permission of Microsoft.

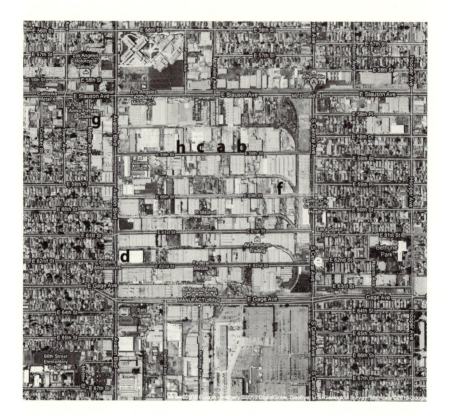

Figure 1C. Aerial view of site #1 in Figures 1A and B. © 2010 Google; imagery © 2010 TerraMetrics.

Preface

Urban tomography, as in medical tomography, makes many images (or videos or aural recordings) of a place or phenomenon from a diverse set of perspectives, allowing one to imagine a whole through its aspects: eight hundred images of the facades of storefront houses of worship (mostly churches) to appreciate religiosity in a city; hundreds of images of the streets of a city before and after renewal (as Charles Marville made photographs of Paris, 1858–77) to appreciate how the city was and how it had been changed; all the electrical stations of the Los Angeles Department of Water and Power (about 150); hundreds of images of working people (as did August Sander, in Weimar Germany) to give concreteness to a population; and thousands of images of people at work at more than two hundred industrial sites in Los Angeles; not to speak of streetscapes, extensive neighborhood surveys, and many sound recordings. Urban tomography is about multiple aspects or slices of a presumed whole, ordinary or typical images or sound recordings. Moreover, we appreciate that whole from those concrete aspectival images. We shall say, technically, there is "an identity (a place, an object, a phenomenon) in a manifold presentation of profiles."[1]

In contrast, there is a tradition that claims that an image or a painting might be a provision of the whole world, the world as a whole.[2] Most visual documentation is provided through such exemplary and extraordinary images, whether in photojournalism or in documentary photography. That tradition would say that images taken as profiles are merely fragmentary. Urban tomography would say that only after we have understood a notion through many examples, only after we have understood an identity through a manifold presentation of profiles, can such an individual image be a provision of the world.

Now, the world is more productive and varied and surprising than

is our imagination; its *this*-ness or particularity or facticity exceeds its genericity, the actual concreteness more productive than ideas or thoughts. There is always more, more than you could intend. So you want to get closer to see better, or get more distant to gain perspective, or survey more widely to avoid lacunae, or enlarge the image to recover further details. But always some things are unavailable, occluded, missed, or not resolved.

The hard part of urban tomography is actually doing the documentation, going out and looking, cataloging and archiving, persisting in finding new aspects, and knowing when you have enough or more than enough so that the whole may be discerned. The institutions and phenomena are ubiquitous. Often they are spatially agglomerated, at street corners or in districts or neighborhoods, not by chance but for good reasons (zoning, economy), or arranged schematically as in a network, again for good reasons such as efficiency. We might learn about the institutions or phenomena, perhaps as a system, from how they present themselves on the street or when we just walk inside or close up.

My exemplary cities will be Paris, chosen for its rich history of such urban tomography, and Los Angeles, where I live and work, providing examples of current work in this vein. A city is an archive of its past. It provides for more than enough slices or aspects so that we might see it more comprehensively, as an identity, as a whole.

This is not a photography book or a picture book. An introduction that explores the phenomenology of urban tomography is followed by four chapters drawing from what I observed and documented and came to understand on specific urban themes: streets and what you might see there; work and commerce; infrastructure; and worship. These topics are central to writing about cities. In each case my fieldwork and urban tomography enabled me to articulate the concrete whole from many aspectival images. In particular, I describe the substantive culture or economy that is displayed in those images. Chapter 6 shows how one might use aural recording to do urban tomography. Chapter 7 brings together theoretical and philosophical considerations about how urban tomography works in practice.

I have documented public and private Los Angeles, what you can see from and on the street and what is behind closed doors, the profane and the sacred. I am interested in commerce and merchandising, health services and real estate, industrial and especially manufacturing work sites as well as people at work at those sites, and utilities and ports and rail yards and warehouses. Public life includes conversations heard out loud, life on the bus and transit, and people gathering together to eat. As for the streets, there one finds background aural ambience, commercial and wholesale districts, neighborhoods, ethnic or religious enclaves,

residential and industrial areas, traffic, and people changing buses and waiting for the next one. On those streets are thousands of places of worship, and some of the time I go inside as well. Infrastructure provides the nerve-ways and arteries that link it all together. There is as well quiet, and much can be heard below the noise. All of these topics are linked by systemic connections and by propinquity, so while studying one you bump into another.

The world is concrete and specific, not a set stage. Every detail matters as it is, and yet you will always miss something. What is everyday and ordinary allows you to not pay attention to lots more that is just as present. There is always more than you can take in, at one time or multiple times. You have to stick your snout into the world: you may use a wide-angle lens (whose horizontal angle of view is perhaps one and a half to two times that of a normal lens) or a widely sensitive surround microphone system (employing several differently facing microphones) to get closer yet not miss what is just nearby, on the side. And you have to be there, do the fieldwork, get closer or go around occlusions, make the documents; and then you have to systematically index and archive them, and review what you have gathered. From manifold overlapping and multi-aspectical images or recordings, from a panoply that may include redocumentation of what was once documented decades earlier, from a cinematic montage of shots, from your initial notions now modified by that manifold—you figure out the whole that allows itself to be presented in these so many aspects, namely, what is going on, its choreography, what the phenomenological philosophers call an identity in a manifold presentation of profiles. Then each image may be seen to exemplify that whole, that identity. I want to make people stop and look and listen, recognizing what they have heretofore passed by, and see that as part of the whole, so that identity is now more encompassing, more accommodating, more adequate.

These chapters are reflections on a fieldwork picaresque and an obsessive search for phenomena, driven by what I have encountered in the field, in Los Angeles, latterly informed by scholarly literature in particular areas. The photographer Walker Evans (circa 1935) put it more directly: "[The] American city is what I'm after."[3] As I say at the end of Chapter 4: Hyperbolically, there is an identity of the various identities in the manifold presentations of profiles. That identity is the city.

In the end it is the fieldwork and the documents that shape what I say. The theorizing here is driven by the desire to describe the world I encountered and recorded, and to account for my practice. The goal is to provide an archive that will be useful decades hence, in ways that I surely cannot fully anticipate.

Three provisos: First, I do not believe that any of the phenomena I

discuss are specific to Los Angeles; that location is just where I have done most of my work. Second, "urban tomography" is meant to be a portmanteau term for the various practices that have relied on very large numbers of related images or documents to get at the world; everything I am doing has almost surely been done before by distinguished artists and social researchers, albeit under different auspices and sometimes less intensively.[4] Third, while "tomography" is a technical term, you do not have to be an expert to read and appreciate multiple aspects, or slices, or tomograms. Tomography is the way we come to know the world ordinarily, every day.[5]

Most of the still photographs and the associated fieldwork date from 1999 to 2006: housing, commerce, and streets; then storefront houses of worship; then industrial streets; then inside industrial establishments; and then infrastructure. My work in video dates from about 2004, in aural surround-sound recording from about 2006, and in multiple video-smartphone urban tomography from 2007 and 2008.

We have established a website that will eventually have much of my Los Angeles archive, visual and aural, available digitally: http://tomography .usc.edu/urban, as well as links to other of our projects. Immediately, it will have some recordings and relevant images. It may be useful to have a list of the main topics in the archive (see also pp. xvi–xvii): houses, storefront houses of worship and worship services, infrastructure including helicopter aerials, industrial streets and neighborhoods, inside industrial sites and people at work, traffic commercial strips and ethnic markets and shopping, restaurants and eateries, industrial and commercial buildings of a large real estate firm, Department of Water and Power sites, streets and behind streets, urban botany, transit and bus life, the Pico-Robertson Jewish enclave, the ports, quiet places, sound sites, events, and marches.

Introduction

Tomography presents the world to us as a suite of slices, multiples that allow us to see a whole through its aspects, whether it be urban religiosity through images of many storefront churches (Figure 24) or urban infrastructure through images of a city's electrical facilities and aerial photographs of utility corridors (Figures 17 and 19)—much as a computer-aided tomogram of the brain, ready for reading by the neurologist, shows her the brain slice by slice (see Figure 15). Or, cinematically, a composited movie consisting of fifteen submovies, each made one after the other, tiling a screen, exhibits some of what is going on in a busy section of a neighborhood (Figure 2), or a multipanel movie of the processes of manufacture in a foundry (Figure 6), each submovie made separately, is, again, much like the multipanel display prepared by a sonographer of the heart's functioning (Figure 3)—from various angles, in various imaging modalities, ready for reading by the cardiologist. Originally many of the medical X-ray studies were done one image at a time, each image slice laboriously obtained by manipulations of the X-ray machine. However, now we as a matter of course produce suites of images or arrays of movies.

The pervasive themes here are everywhere at one time, every time at one place, causality seen not only in time but also in the spatial array of images: streetscapes, people in motion, multiples of a particular kind of activity, angiograms of links and nodes, and choreographies of work and worship. There is overlap, complexity, layering, and slices of life. The stories are cinematic in that they are time based and screen based, and may even employ the conventional devices of cuts, montage, and bricolage.[1] But they are not movies as we usually understand the term, where conventional narrative rules. Here the story may be about the

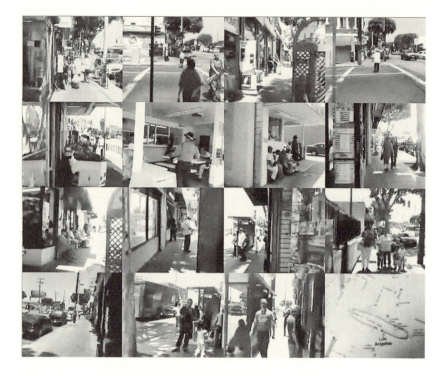

Figure 2. Multipanel view of street activity on East César E. Chávez Avenue near North Soto Street, Boyle Heights, Los Angeles (Figure 1A and B, #3).

nature of a particular process or institution. These tomograms, slices in space and in time and in typology, are sometimes displayed as videos or motion pictures, sometimes displayed as a high-multiplicity array, and sometimes both.

You bring curiosity and knowledge about urban processes, or of physiology, to these imaging modalities, whether as an expert or as a layperson. Surely, the images are pretty, but their value lies in what they allow you to imagine about what is going on given what you see in those images and what you know already. Of course, the echocardiographer edits the images and brief videos, choosing ones that will be most indicative for the physician, but it is the physician who watches these movies, bringing to bear narratives of cardiac function, structure, and pathology. The multiple movies and images are what the phenomenologist calls "aspectival variations," allowing the viewer to imagine a whole, a notion of what is being displayed, a process or an institution that would produce these aspects. There is an overload of information but presumably just

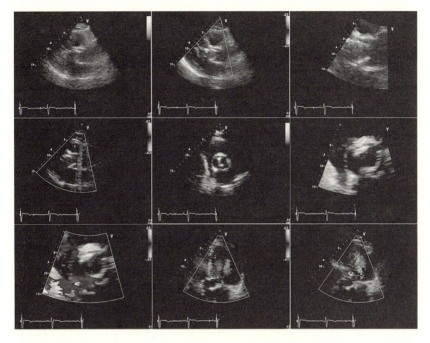

Figure 3. Echocardiogram, nine out of forty-five video views.

one idea.[2] Each image is indexed by the name of the aspect it displays, or its geographic/anatomical coordinates. The reader of these images can use this information to help find the images' places in the prospective whole, employing imagination and perhaps with the aid of a display that organizes the aspectival images.

In doing urban tomography, I have deliberately photographed a very large number of houses of worship and industrial sites, as well as all of Los Angeles's electrical stations. One must include so many images, so many aspects in a tomogram, for assurance that the corpus of images is comprehensive and representative and to allow for what might be called phenomenological knowledge in terms of multiple aspects.[3] Moreover, the extent and diversity of the documentation allow you to take seriously displayed signs and symbols, the actual presence of these places and institutions in the city, their scriptural or technological or societal references.[4] What might have been taken as idiosyncratic or without significance is now seen as ubiquitous and meaningful.

The reader might well ask, why these particular topics: churches, factories, streetscapes, aerials of utility corridors? The straightforward answer is that they follow from walking and driving the streets of my city, from

discoveries made in the course of doing something else. Driving to work I eventually noticed how many storefront houses of worship there were along the way. When photographing such houses of worship, I discovered industrial Los Angeles across the street. When I walked down the industrial street photographing facades and streetscapes, I was invited in to look at the factory itself. When I asked if I might photograph other such sites, maybe one in three such inquiries was answered affirmatively. Taking the bus to work I discovered the richness of publicly hearable conversation; and, of course, cell phone half-conversations are ubiquitous. (One might ask, just what are people's expectations of privacy?)

Eventually, I realized that I am never interested in one image or one site or one aural recording, one spectacular shot; rather, my interest is in many such sites and images. I realized that one-more is an unending temptation. And during an echocardiogram I realized that I have been doing much the same as does the sonographer, but now for a city's phenomena.

As the chapters show, there is good reason to believe that each of these topics is rich and connected to how a city works. Work, infrastructure, and worship would seem to be fundamental components of a civilization. But what is most striking is how these topics are by the way encountered in the documentation work.

What We Might Know about a City

In *The Critique of Pure Reason* (1781), Kant took on the skeptical tradition that denies that we might have complete and total knowledge of the world, by making clear what we might mean by scientific knowledge. Such knowledge is a product of our faculties and their capacities, and, as important, the logic of our thoughtways. We cannot have knowledge of things in themselves, only as they are *for us*. There are limits to what we can know, limits to certainty and completeness. By staying within those bounds we can have scientific knowledge.

What can we know about a city and its sensorium? I am here concerned with aspects of the city that are available to sight and sound, although smell, taste, and touch often enhance those senses. It is through tomography that such knowledge is evidenced. Tomography is many slices or aspects or perspectives on the world, claiming that they are picturing the same thing, albeit from different angles. In effect, it is a claim that there is unity in multiplicity, identity in manifolds.[5] Whether that tomogram is of the brain in a CAT scan or of the heart in an echocardiogram, or of the facades of storefront houses of worship in Los Angeles, what we are offered is a multiplicity of images or videos about the same thing, or so

we initially believe. We employ those slices to articulate a more detailed understanding of that thing, whatever it is. We start out with a notion of that unity or identity or thing, and through that multiplicity we modify that notion so that it can more adequately provide for that variety in that multiplicity, so that the notion is more accommodating.[6] We have some idea of what we are looking at already (the particular organ or thing or notion) as we examine each image separately; we are filling in the details, figuring out, an *imaginative draftsmanship*. Tomography allows for, it presumes, such identity in manifolds, many images showing us a world or an object as we encounter it from different aspects.

More generally, the project is to document a city in terms of multiple slices in space and in time and in type (hence *tomography*), a unity in that multiplicity of aspectical variations (a *phenomenology*), showing how people, machinery, and nature work together or coordinate to get the city's work done (a *choreography*). Denis Diderot (circa 1760), Charles Marville (circa 1860), and Eugène Atget (circa 1915) once did much the same for Paris, in systematic surveys and multiples. Ordinary everyday life, in its tissue of negligible detail, is rich and deep, and through tomography we discover that detail in the context of an encompassing understanding of the whole.[7]

The cinematic arts and opera are suggestive models. The cinematic arts are concerned with multiple slices and cuts, compositing, storytelling, and screen language.[8] In opera, the claim is that music, sound, and visual action form an indissoluble whole. In both cases there is also the claim that repeated viewings or performances are rewarding, your noticing and appreciating new things each time around as well as recalling what you have already taken in, perhaps radically revising your understanding of the work. Both also allow for multiple scenes on the same screen or proscenium, each playing against the other.[9]

Slicing Up a City

A tomograph is a knifelike device meant to section or cut thin slices of tissue. Computer-aided tomography uses thin, almost one-dimensional X-ray images, or "pencils," of an object to construct a two-dimensional image of that slice of an object, and presumably those slices can then be fitted together to get a three-dimensional model.

We slice up a city or a type of phenomenon or a process through multiple aspects: photographs of the facades of many storefront churches allow us to appreciate urban religiosity as a diversely manifested phenomenon; photographs of the merchandise displays in ethnic markets show the variety and the similarities of urban subgroups; and photographs

or videos of the various aspects of the casting operation in a foundry (Figure 6), forming an album, provide what we need to imagine the whole process.

Most urban situations are complex and varied and have many temporal aspects. To document a street market we need images from various perspectives but also of different sorts of transactions, of the insides of the booths, at various times of the day or week, and so forth. In addition it would help to interview the participants to discover their accounts of what is going on—in effect, additional slices or aspects.

We might capture such a situation or phenomenon one at a time, using still photography or audio recording. But now there are inexpensive sensors available and sufficiently ubiquitous to document urban life more pervasively, to provide a very large number of slices or aspects—unlike our experience in 1963 that resulted in just one movie of President Kennedy being assassinated. Namely, video-equipped cell phones are such sensors, and they are carried about all the time. We might imagine a *swarm* of such users (that is, crowd sourcing) documenting an event or situation, each from his or her own perspective or interest (Figure 5).[10]

Such a corpus of images, videos, and sound clips, less as a set of disjointed pieces of a puzzle and more as a series of differently detailed renditions with the documents labeled and organized by location and time and perspective, allow us to better know the whole that is here presented aspectivally.[11] Ideally, we have lived in this place or we have already done fieldwork ourselves, so we have some idea of what that urban world is like. We start out with a sense of what there is in a city and can fill in and modify our initial notions, check them out, and learn more. Urban tomography leads to a fuller sense of place and activity.

The actual city is an archive of repeated forms and structures and designs allowed to age, repair, and renew themselves. The ubiquity and variety of these forms in a city are products of the political economy of real estate development and decay, the rise and relative decline of neighborhoods under the influence of larger societal forces, and a politics of public choice for support and subsidy.

So the city itself is an archive of its past, much as a population is an archive of its past (as the evolutionary biologist would say). However built and for whatever reason, much of the built environment lasts well beyond its planned lifetime, perhaps rebuilt and repurposed. Speculative building of a large number of similar structures, whether they be stores or homes or industrial buildings or office buildings or factories, means that many structures have many identical representatives. In time each particular building is altered to suit its current or prospective owners; some buildings are destroyed, others restored. (The usual example is a planned urban development, as in a Levittown, fifty years

after opening.) New uses make what once appeared to be doomed neighborhoods or building types into lively, productive, and economically viable places and enterprises. A real estate market that allows for these processes will eventually produce a city that has a wide variety of what were once similar buildings and uses, likely to be spread throughout the city although not in all areas. What was once repetitive and the same becomes variegated and diverse. Development alters the consequences of genetic endowments. Moreover, new uses tend to be agglomerated in certain areas, there being good reasons to have competing enterprises located near each other. Yet those enterprises also specialize, providing for a wide range of niches. So might the story of urban economies be told. The storefront houses of worship we see when we drive around town are products of just those processes that have built and rebuilt cities, especially since industrialization.

What an archive provides, what a built city provides, is a range of possibilities and instances, which then become inhabited in ways we do not foresee. The artist Frank Stella made a series of works (sculptures, paintings, prints), one or more for each chapter of *Moby-Dick* (which has 136 chapters).[12] Even knowing *Moby-Dick* well and Stella's previous works, it would be difficult to predict how each chapter would be instantiated and the range of the instances. However, *Moby-Dick* provides Stella with the chance to make works that form a series, an archive, a meaningful whole, each work, however, on its own. So the city too provides for its inhabitants places and spaces to make their lives meaningful and whole.

Choreographies of Repetition

So we might have an account of industrialization, but now that of the Second Industrial Revolution and the great migrations that have continually populated the City of Los Angeles: the interrelated choreographies of where and how people worshipped and worked, and the engineering—industrial, civil, chemical, and electrical—and the coordinated networks and systems and infrastructures that supported industry and residents and that allowed them to live close by each other.

The Second Industrial Revolution made possible photography, radiology, and the images we can make, and the images reflect possibilities built into the technologies of cameras, lenses, films, and X-ray machines, now an ongoing transformation from the analog film to the digital sensor domains, from colloid chemistry to digital electronics. What was once a black art of emulsion manufacture is now another black art, the design of algorithms for processing sensor data or pixel information in the digital file. Much the same has taken place in the world of aural

recording and reproduction, albeit microphones (and lenses too) are not digital devices.

The studies I discuss here are, in effect, a repetition of a past history, now in Los Angeles rather than Paris. As for Paris, I am thinking of Denis Diderot's (1713–84) description and engravings (Figure 7) of workers in the *arts et métiers* for the *L'Encyclopédie* (1751–60ff), Charles Marville's (1816–79) photographs (1858–77) of the streetscapes of Paris before and then after Haussmann eviscerated them under Napoleon III's direction (Figure 4), and Eugène Atget's (1857–1927) systematic photographing of Paris's streets, stores, monuments, residential interiors, parks, and workers in the early part of the twentieth century. Perhaps a consequence of Cartesian philosophy that truth is systematic, the models here are French. There is the impulse to image and catalog and to archive, to be descriptive and encyclopedic, to take city life seriously and systematically—and to be aspectual and empirical. D'Alembert in the preface (1751) to d'Alembert's and Diderot's *L'Encyclopédie* tells us they had to go to the workers themselves to draw out from those workers the details of processes of manufacture and craft, and the encyclopedists needed figures or pictures to articulate and convey that information.[13]

We know a little about how Marville and Atget went about doing their work. They were systematic, especially Marville, following a plan provided by their employers or commissioners. Marville was likely given a list of streets that would be pierced/eviscerated and later a list of streets now reconstructed. Atget may have been commissioned to update Marville's survey.[14]

Marville might have gone down a street and then up the same street, making several down- (or up-) the-street images along the way. Streets were often adjacent or intersecting, and so there were overlaps and multiple views of the same places. Atget progressed through the space in a more panoramic way, with multiple angles and overlapping viewpoints, and from the overall to the detailed.[15] In effect, they were doing urban tomography, *avant la lettre*, providing a rich set of aspectual variations, allowing one to imagine what the street or place was like so that it could accommodate these suites of images.

City life is produced by material and ordinary circumstances. So if newspapers are to be sold, there will be vendors or vending boxes at certain corners; if there is to be worship, there must be places available for that worship. What is everyday and ordinary is as indicative and richly symbolic as is the extraordinary and unique. This is the stuff that we take as given, as natural, as background for what else we are doing. Often it is visible, and sometimes it is audible.

An urban tomography may document systems, for what is apparently idiosyncratic is in fact deeply embedded: many storefront churches, all

the electricity-distributing stations, or the various firms in an industrial or manufacturing sector. (The various objects might not be intended as a system, but they function as such, for example, producing for each other as well as for end consumers.) We present the world back to ourselves, in its ubiquity and variety, so it is recognizable—even if not in the manner we ordinarily see or hear or even ignore these places and objects. Each document presents us with an aspect of the whole; we make that image or sound recording because we believe from past experience and theory it will so contribute. Yet once we understand what is going on, any particular single document does much of the work of encapsulating what we know. The very detailed and particular example or image, itself, can now make a larger statement.

There is a drama and a choreography in everyday life that give it meaningfulness, an overarching organization of plot, role, and movement: what we are up to, at various levels of detail, and how we work together. The everyday is significant; the ordinary and unnoticed has its own drama—a drama that is taken as unremarkable, until it might fall apart in pathology and dysfunction. So an analytic description of the drama and the choreography of an industry shows the materials and initial processes, the way people work together and the ways they manage mistakes, the major products, the tools and machines, the workmanship of the craftspersons, and the terminology as it is embodied in practice, much as Diderot would have prescribed. And these aspects are shown to be *aspects of,* aspects of a meaningful activity, say, making something, or aspects of an object or an institution.

Any story is present in several media modalities. The modalities inform each other, so that when you record in the best of surround sound, in listening to the recording you will imagine a visual image of the place and of what you are hearing. Cardiologists place themselves within the beating heart, not as novelists but as informed sensors of the heart's functioning.

What you encounter again and again is the world in its variety, repetition, and ubiquity, where there is always more, and just when you thought there was a plethora, there is more again. In effect, we are looking at threads of the urban fabric, each thread linked to the others, so that what we see in detail up close is seen as being located within a larger context.

No generalization will erase the facticity of each image, its unavoidable particularity. The *this*-ness of the world exceeds its genericity.[16] Tomography allows for both. If details and particulars are instances of generic notions, there are other unavoidable details and particulars that are not under the command of the generic. Hence the world is recognizable to us in its particularity, no matter how powerful are our categories and genera. This is *my* echocardiogram, not that of an abstract body.

In cataloging a phenomenon, the aesthetic and the compositional are in tension with the practical and the depictive. But the actual image must be all of these. So, for example, photographers for the Library of Congress's Historic American Building Survey and Historic American Engineering Record insist that a well-composed and properly lit photograph will also be more informative and depictively effective than one lacking those qualities. The aesthetic and the practical would appear to be very much of a piece.[17] The catalog and the multiple video echocardiogram are ways we insist on unity in multiplicity, that it is through aspectival variations that we know about the world and its potentials.

Rephotography as Repetition

Public health crises, war, political transformation, and natural disaster have often been occasions for the reconstruction of cities. But as insidious is the influence of economy and technology, creating new opportunities and obsolescences. Still, what is most remarkable is the persistence of the built environment (unless it is deliberately destroyed). When Charles Marville was asked (1858, 1865, 1877) to photograph the streets of Paris, it was presumably to show the before and the after: the positive transformation, the hygienic and aesthetic improvements. Marville was the official photographer of The City of Paris, and was a formal part of Haussmann's enterprise, commissioned by the Service des Travaux Historiques. Marville's charge was to preserve the memory of the past, rather than to regret the decision to clear away the underbrush that had grown in Paris and that made it an unhealthy place.[18] Marville left a systematic suite of images of monuments, green spaces, urban furnishings (public urinals, streetlamps, fountains), and of the streets themselves, which we now might employ to imagine a way of life that has disappeared. Still, what is remarkable is how much of that earlier urban fabric remains today.

Now rephotographing past scenes is standard practice for those concerned with documenting changes in the landscape and natural resources, and this depends on there being an archive of earlier photographs. Art photographers have adapted this practice for their own purposes: Mark Klett (nineteenth-century photographers of the western United States); Douglas Levere (Berenice Abbott); Christopher Rauschenberg (Atget); and Ed Ruscha (earlier Ruscha). Jeff Wall and Eleanor Antin photograph restaged events, imagined or adapted, sometimes portrayed in earlier visual works.

Rephotography is often done with rigorous demands on being at the right viewpoint to duplicate the original photograph's perspective, the

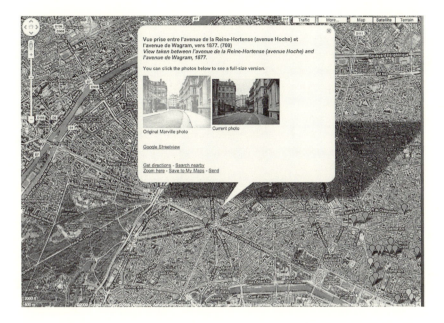

Figure 4. Screen shot from http://www.usc.edu/sppd/parismarville. Photographs of rue de Tilsitt (near Place d'Étoile) by Charles Marville, 1877, Bibliothèque Historique de la Ville de Paris; and by Fritz Koenig/ Tom Holman, 2008, used by permission. Website by Kazuma Kazeyama. Map © 2010 Google; Imagery © 2010 Digital Globe.

right time of day and time of year to duplicate the shadows, and an appropriate focal-length lens to duplicate the extent of the earlier image. In summer 2008 I asked several colleagues who happened to be in Paris to rephotograph some of Marville's images. I gave my colleagues maps and copies of the original images. They had the task of finding the right points of view, and I encouraged just a reasonably good approximation.[19]

The scene I have chosen (Figure 4) shows how enduring is much of this urban fabric, in part because Marville's is an after-reconstruction photograph (~1877), and so perhaps the buildings and streets might well persist for 130 years. But even in Marville's before-reconstruction photographs (1865–68), quite often there are features or buildings, sometimes in the background, that are seen in the 2008 rephotographs.

There is lots of room for further work in this vein. In the last few years various private firms have systematically photographed the streets of major cities, and made those images available on the Internet. Google. com's *Street View*, with its twelve-camera van; pagesjaunes.fr in France, with its squad of photographers going up and down the streets; and

bing.com's oblique aerial views (provided by Pictometry) are perhaps the most well known (as of early 2010). So if you have an archive of old photographs (say, from a newspaper morgue or a utility company's files), you may do armchair rephotography—although it is likely that the perspectives provided by the private firms will only roughly approximate those of your earlier images. On the other hand, a slightly different point of view reveals important facts, since it is easy for occlusions to occur. We are in a three-dimensional world, and our images are from particular vantage points at particular times.

Swarming as Tomography

Imagine sending out a swarm of people or a troop of scouts into a market or crowd, or imagine a crew of celebrity watchers outside a Beverly Hills restaurant, each person equipped with a video cell phone. The resulting number of videos would be large. Rather than edit or try to conform them to each other (as in a montaged panorama), we might display them all together on one screen in a tiling, with locations and times indicated by maps and clocks. If we are fortunate, we have various scales portrayed, from overviews, inside and out, and at various angles, to many different detailed individual interactions.

We are informed and curious inquirers, and so we bring along notions about what goes on in cities and what we might look out for. By means of these slices in space and in time, we might have the sense that we are looking everywhere at all times. Still, there are likely to be lacunae. Real-time monitoring of the inflow of videos might allow the viewer to send commands to the swarm or troop to focus in on certain places, to get more detail about a particular activity, or to spread themselves out.[20]

We might infer which point in space and time is being examined at each moment in a video. We link (in our database) multiple views of the same space and time region. The places we are looking at are quite varied in their structure, with occlusions, multiple layers, and multiple foci of interest. Ahead of time we know little in detail about a place's organization, which itself changes in real time, but we do have general expectations from past experience. However, that organization is not at all fiducial: for everyday life, you cannot just say something such as, let me look at the left ventricle of the heart from below, or part of the Earth's surface at latitude-longitude Y–Z, at time X, under a particular range of the electromagnetic spectrum. The everyday world is rarely so fixed and specified.

Even so, you already have *some* idea of the organization of the place or process, perhaps even a wrong idea, and in the process of examining

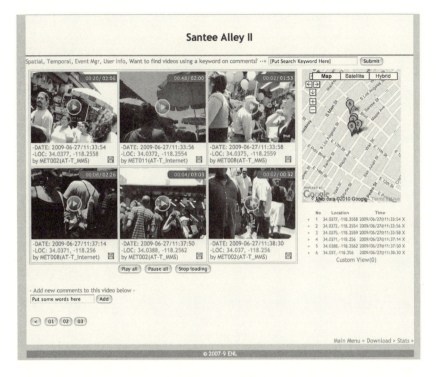

Figure 5. Multipanel display of videos produced by three cell phones at Santee Alley bazaar in downtown Los Angeles (Figure 1A and B, #20). tomography.usc.edu.

the various vignettes you are filling in that schematic organization or perhaps questioning its capacity to accommodate this or that vignette. You do not *figure out* the structure from the vignettes; you *fill in* a presumption, if that presumption is sufficiently accommodating. (If "figuring" is given the literal interpretation, in terms of drawing a figure, then perhaps you are *figuring out*—that act of imaginative draftsmanship.)

Consider a simpler situation, taking many video clips of a well-defined site with just one camera: a video album. Sometimes the world as such is available to us as a patterned, organized whole, as when we enter a small foundry and just look around, perhaps sketching a plan of what we see. Still, we might find the scene overwhelming in its detailed activity. The aspectival variations provided by a video album, viewed again and again, help make sense of the place; yet in our having looked around, we already have a sense of the whole place, albeit perhaps not yet a sense of how foundry work is done, the processes and the flows of materials. So we might spatially organize the vignettes rather more precisely than

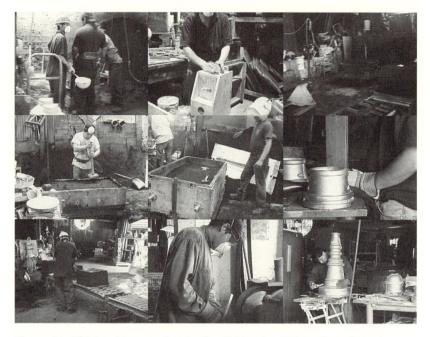

Figure 6A. Mold making, casting, and polishing in sand casting of metal: foundry, downtown Los Angeles (Figure 1A and B, #4).

is provided by geographical positioning (GPS) information, following our plan sketch. Still, the various processes and how they interact may remain rather more opaque. We might infer what is going on by looking at the flows of materials from one vignette to another, arranging them in process order rather than spatial order (although the design of a workshop, or of a factory, should make the two reasonably congruent). Moreover we already know lots about materials, that heat makes things flow and cooling stops that flow, and so we bring physical science to our viewing of the vignettes. To make sense, the place must be organized spatially and processually and in accord with the physics and chemistry of materials. And, of course, as did Diderot, we might ask the people who work there what is going on.

Or perhaps we visit a vast and sprawling high-end forge, with monstrous presses, ovens, and sophisticated milling machines. While the individual images or videos give us a sense of each of the activities, still we need a layout diagram of the forge to locate them in the space and time of this industrial complex. We cannot see all of it from a single position. It would help to take notes on what we are told by the foremen and to be able to ask them questions on a return visit. In addition,

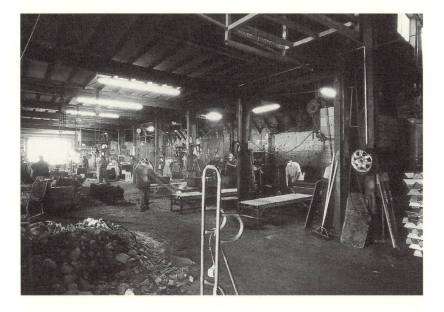

Figure 6B. Overview of foundry floor: ingots at far right (the oven is nearby but not in the picture), ejected sand from castings at far left, and men preparing, pouring, and cleaning castings in the middle ground.

as with the foundry, knowing about the physics of metals would have made sure that our story made technological and scientific sense.[21] In each case we might want to know about how people work together in dangerous but mostly predictable work environments—presumably in well-choreographed groups.

Once the place makes better sense, the video clips are now seen as aspects of that place, that foundry, that industrial process and its machinery and its workers. Yet it is those video clips and our sketch plan and our interviews that enabled us to articulate more adequately this place's sense and meaning.

A place might be a neighborhood street rather than a formal site. Having made multiple videos of an ethnic neighborhood's main street, such as East César E. Chávez Avenue in Boyle Heights, Los Angeles (Figure 2; Figure 1B, #3), we discover who is on the street at 11:30 A.M. on a weekday in Boyle Heights—elderly adults and mothers and children, or people who are not at work or school—complementary to what is seen at our work sites. The aspects or video clips are aspects of work and family life in an ethnic working-class neighborhood. Much of this is obvious once seen, but perhaps less so ahead of time and likely less obvious fifty years from now.

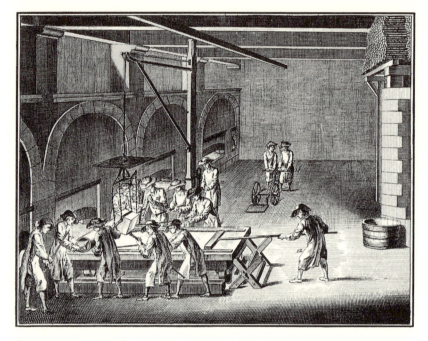

Figure 7. Engraving showing the making of plate glass, from the *L'Encyclopédie* (~1760).

The World Is Consistent

I have been focusing on the visual and spatial aspects of phenomena, but the aural and temporal ones are as significant. If we have multiple video vignettes taken by multiple cameras, the soundscape is likely to be shared even more than is the landscape. Sound is everywhere, sneaking up from behind, diffracting around corners. Images of different nearby places may well share sound content, albeit the sound is likely to have a different quality depending on where we are looking and listening. Yet we believe there is just one world, one identity that provides those multiple profiles. So the sound in different vignettes must accord with each other and with what we see. That is our working presupposition.

More generally, video tomography makes us rather more acutely aware of the phenomenology of perception and understanding, since it provides for greater complexities in those acts of finding identities and filling in their detail than are demanded by multiple still photographs or even multiple sound recordings of a place or type or process. What

is remarkable is that often we are able to figure out what is going on through such documentation and get a fulfilling sense of the richness of the city. It is not that greater detail solves the problems of documentation; rather, it demonstrates further our ability to figure out the world, fulfilling its possibilities: an imaginative cinematography.

Tomography, with its multiple images and aspectival variations, is the archetype of what the phenomenological philosopher teaches us about unity in multiplicity (again, "identity in a manifold presentation of profiles"). We start out, always, with some sense of what we are seeing—in space, in time, and in type. The multiplicity of aspects allows us to fill in that notion, satisfying or disappointing our expectations.

Seeing Wide-Angle Deeply

The cameras and wide-angle lenses I use for still photography, having 70–85 degree horizontal angles of view, allow me to be at a distance a bit less than the height or width of a storefront's facade.[22] That is, I am still on the sidewalk or just in the street, and yet I can incorporate into my photograph the almost-square facade of a single store's width and height, including the sign above the front window. Everything is in the frame. My viewfinder has a bubble level in it or an alignment grid, so I can be sure that I am not tilting the camera up or down, or to the left or the right—so squares remain square in the image.

Nor am I distant from people at work on the shop floor or at a worship service, for I am quite close to the first rank of these people in front of my camera. Often in these situations I have carefully pushed my wide-angle snout into their work space or worship space, using an unobtrusive camera, no flash or tripod, and moving quickly but respectfully.

Moreover, I am close enough so that little is in the way that might occlude the facade or the work site—although a large piece of machinery, or a tree, or a parked car or truck may be unavoidable. (The sun may be coming up over the roof of the building, or the indoor lighting might be aimed at my lens, and then I must photograph obliquely, rather than frontally, to avoid lens flare.)

For an individual facade, not much of the surrounding environment is in view—except for the sidewalk, the cars, the street furniture, and the walls of adjacent buildings. The facade is just there, in front of me—a particular facticity. Yet if I photograph facades, going down a street one building after the next, each image overlapping the adjacent one, say on a strip of 35 mm film, each facade is now seen in context.[23]

For indoor landscapes of industrial sites, even though I am close in, the depth of the scene incorporated by the wide-angle lens brings

tantalizing detail into view.[24] The image has enormous reserves of quality and detail—the lenses are that good.[25]

What is striking is how much is left in within the image, what is carved in by the frame lines of the negative or the sensor, including things in the background. You are forced to be right there rather than distant. Moreover, whatever occludes your ostensible subject, that in-front-of stuff, such as a parked car, is significant in itself—and may someday be what you are really interested in, much as you might be interested in what is in the background, what is not focused on. Getting closer, some of the once-occluding objects are behind you.

To have a large angle of view means that you see much more of the objects you are photographing. More of an object's shape and the range of its shading will be part of the image. The tonality will be more varied. The continuity of surfaces and the presences of edges and bends and cracks (the shapes of things) are more fully given, so that surfaces, edges, and bends are not merely local facts but are global geometric and tonal facts: the shapes of things, what they look like when seen.

For the most part, these sites were not meant to be photographed, although they are readily accessible. These are sites meant to be lived in, worked in, worshipped in, in the matter of course seen but not imaged. I am not a photographer but just an "old man with a camera," as I was once described by a metalworker at a factory. Or, as the filmmaker Jean Renoir put it, "My aim was to give the impression that I was carrying a camera and microphone in my pocket and recording whatever came my way, regardless of its comparative importance."[26] I am interested in the world, not the photograph, not "the shot," not the archive of photographs as artworks. The photographs make it possible to see what is there in front of your eyes, now unavoidably so.[27]

The material was there for anyone to see, but it required *fieldwork* to find enough of it so that it could be taken to be a phenomenon, *systematic* work so that what I saw was not taken to be idiosyncratic, and *reflection* to place what I discovered in a larger scholarly context. So discoveries become objective phenomena.

To do this sort of fieldwork one must have extensive examples of the phenomenon of concern. Once you can provide those examples to others, they might well be convinced of the reality of the phenomenon and then be quite comfortable with just a few examples. But fifty or five hundred examples are the most effective inoculation against skeptics.[28] It helps to be able to provide rich overlapping theoretical insights from various disciplines, so that what is perhaps peculiar or unnoticed is now seen as indicative of a much larger range of facts and situations. In addition you must show that what you have found is not just a chance occurrence—numbers help, but maps of spatial distributions and other such will also help. Finally, you will

need good taste or good fortune in your discoveries, for some ubiquitous phenomena may not be as illuminating as are others.

In order to make such discoveries, your fieldwork has to be relatively unencumbered by looking for something else. You have to put in the time and effort, and you will almost surely do most of your work on foot (or, as in some of my work, from a helicopter) or be present to actual working people (in a hospital or in a factory).

You have to be able to tell a story about what you have found that is rich in its connections with what everyone would seem to know. You will have succeeded if people start noticing the phenomenon you have identified and think it is obvious—when, before they saw your work, they saw nothing of interest. In the natural sciences, such discoveries have always been of very great import. In the social sciences, we sometimes forget the importance of phenomena, subjugating them to theory and theory testing. Our sensory world cries for identifiable phenomena. The phenomena or processes or objects or places become identities that are seen to provide for that manifold presentation of profiles or aspects. In Chapters 2 through 5 I try to exemplify wide-angle and deep documentation, showing how the world produces what we see.

Lee Friedlander's City

Whether through images of monuments in the middle of cities or images of parking lots on parcels eventually to be developed, the photographer Lee Friedlander (b. 1934) has shown us how our cities are ironic and planned and layered and juxtaposed and discordant. A typical Friedlander photograph will show a chain-link fence up front, a high-rise office tower in the distant background, both in sharp focus—in between those two a concrete block wall separating two parking lots, and in the near foreground Friedlander's shadow.[29]

Friedlander's point of view is rarely plan, axonometric, or frontal. Rather, for example, he wonders, what does the world look like to a baby in a carriage, while the baby is on her back? He finds those most available of places to stand, the parking lots and the backyards and the sidewalks, and then photographs what is in front of him, layered by all the stuff in between. Again, there is enough depth of field for all to be in focus. The wide-angle lens of his camera is superb to the edges, so everything has more than enough definition.

A city is a juxtaposition, a clash, a discomposition, since no one controls everything and the possibilities for development are extensively and inordinately explored, much as grasses and mosses grow in every concrete crack. While much of the city is constructed to be seen (although

not the parts I have focused on), with those wonderful architectural photographs or engravings representing that goal, in fact we see it from inconvenient places as we go about our business, but then we edit out the inconveniences in our memory. Camera and film are less readily blind in that way. Friedlander's camera and film capture the way things are, not necessarily but casually, opportunistically. The layers and planes are not so well aligned as we might hope, they clash with each other, and what is backstage is often in front of what is supposedly the main show.

A friend who knows Friedlander tells me, "Lee would never own up to being a critical/serious observer of the dynamics, etc., that determine the nature of what a city looks like, is. He'd just mutter something about just wanting to make a picture out of the elements at hand." Craftsmen work this way. (If I recall correctly, Friedlander once said something like, "I'm just a worker with a tool in his hands," referring to his camera.) Craftsmen know what they are doing, and it sort of all adds up, but that takes time and revision and learning to see the work as a whole, perhaps with lots of extra parts.

Chain-link fencing, plate-glass windows, riotous overlappings of plants or objects or people or cables and pipelines, and detritus such as broken concrete barriers are recurrent elements in Friedlander's photographs—as they are in actual cities. Empty plazas, isolated buildings, and manifestly fake siding are ubiquitous. Everything that is possible is instantiated; all is in a larger context that displaces it from its more immediate situation; juxtapositions remind us that not everything obstructs everything; and almost everything peeks through and montages. The coincidences are there for the taking, the overlaps ever present but filtered in our memories by our being up to orderly and meaningful lives.

Industrial life and work and plants and shrubbery are some of Friedlander's other recurrent themes. In each case whatever we take as formal photography of buildings or plants or places is displaced by a larger, more encompassing vision that is rather more disturbing even if it is just as accurate and just as seen. People at work are not merely at work, but they are fixed in place, almost trapped by his electronic flash. They are part of the machinery or bureaucracy, and yet they are not mechanical, not functional.

I suspect that Friedlander would say he is taking pictures of just what is there. By its repetition of themes, by its variety of perspectives and slices of city life, Friedlander's work as a whole is urban tomography made into art.

Cities, Streetscapes, and the Second Industrial Revolution

The next five chapters tell the stories, historical and economic and sociological, I have learned from doing the fieldwork and making visual, aural, and video documentation. I discuss how the images display those stories, and so how urban tomography investigates and reveals city life. Urban tomography allows one to imagine more adequate identities in that manifold presentation of profiles. In the fieldwork, you discover properly commodious identities, ones that better accommodate the various aspects. The stories I am telling are just those identities, stories that accommodate the documents I have made. It will be useful to begin with some fieldwork reports.

Union Central Cold Storage, Inc. (Figure 1A and B, #11), has an icehouse that was opened in 1908 and an adjacent cold-storage warehouse that dates from the 1950s, with more recent add-ons. It sits on three acres of land on Industrial Street on the east side of downtown Los Angeles, right off South Alameda Street. The land has become so valuable that the owner might sell it, move his plant to an industrial city several miles south, and refit a warehouse there so that it becomes a modern cold-storage plant—replacing an accumulation of added-on pieces of building and equipment at his old site. And, at least initially, the new owner might just demolish the Industrial Street buildings, pave the site, and use it as a parking lot.

SAC Industries on Avalon Boulevard at East 62nd Street (Figure 1A and B, #1; Figure 1C, "d") has slowly but surely absorbed more and more buildings going east on East 62nd as the firm has expanded. What was once their focus, on end-of-runs in metal manufacturing and less than perfect metal stock, now also includes a very substantial used-clothing sorting and resale enterprise. In each case the proprietor's skill is being

able to buy vast quantities of less than perfect goods, sort them into bundles of goods that have shared qualities, and then find markets for those bundles.

SAC is located within a large superblock of industry, the Huntington tract, from Slauson Avenue to Gage Avenue, from Avalon Boulevard to Central Avenue (Figure 1A and B, #1; Figure 1C). (There is as well an adjacent superblock south, from Gage Avenue to Florence Avenue, the Goodyear tract, referring to a large rubber tire plant that used to be there.) The Huntington tract was threaded through and delineated by railroad spurs from the Slauson Avenue line of the AT&SF (now the Burlington Northern Santa Fe). Eventually the surrounding areas were developed as residential (an aerial photograph, Figure 1C, makes this apparent). Those residents might supply a labor pool for the industries in this area. Also, the rents are comparatively low in this superblock (say $0.40/sq. ft. several years ago). It is old (for Los Angeles, having been developed in the 1920s onward), and the current firms have reoccupied buildings built for other purposes originally and subsequently. Just outside the tract, across the streets—lining Avalon Boulevard, Central Avenue, and Slauson Avenue—a large number of industrial and auto repair establishments can be found. Across Central Avenue there are some peculiar commercial establishments: the terminal for pushcart ice-cream vendors in the area; a store that sells chickens killed on-site. Several blocks north, on Central Avenue, a new school is being constructed (Figure 1C, "e"). For less than two hundred feet into the adjacent areas, on the east and west, and perhaps five hundred feet to the north there is a fully residential district, with churches, single family homes, yards, and so forth.

More generally, these industrial neighborhoods might be said to have been abandoned by first-class uses, but they are still occupied by highly productive activities. Their abandonment or depreciation or filtering-down has made them ideal locales for businesses and residents who cannot afford better or who do not need to be first-class. The fact that they are polluted areas, mixing what should not be mixed, is just what makes them successful. The system of repurposable buildings is a resource in an industrial ecology of labor, pollution, economic factors of rentals and materials costs, and other firms (nearby) from which they take materials, process them, and move them on to other businesses (eventually, not so nearby).

I kept discovering industrial areas while going around the city or looking at maps and aerial photographs (in the aerials the industrial areas appear manifestly different from the residential areas): the Eastside Industrial District, east of downtown, along the Los Angeles River; the Alameda Corridor; the Central Manufacturing District, now part

Figure 8. Clarence Street, Pico-Aliso district, Los Angeles (Figure 1A and B, #2).

of Vernon; the Metropolitan Warehouse District, along Union Pacific Avenue; the City Industrial Tract, north of Boyle Heights; and such cities as the City of Industry, Vernon, and the City of Commerce.[1] I came upon Union Pacific Avenue (Figure 1A and B, #7) in the course of the project documenting storefront houses of worship in Los Angeles. Sure enough, to the north especially, there is an adjacent residential neighborhood (and hence the churches listed in the telephone directory that led me there). However, on the Avenue, and mostly toward the south and the railroad yard, there is a rich and compact industrial neighborhood threaded through by well-used railroad tracks. In places the residential and the industrial are interdigitated, reflecting historical

precedent and changing usage and zoning, creating a remarkable urban fabric.

The Pico-Aliso district (Figure 1A and B, #2) is a residential and industrial area on the flats below Boyle Heights, across from downtown Los Angeles, and just on the other side of the Los Angeles River. I got off the 10 Freeway at 4th Street, went west down the hill, and made the first right. That was Clarence Street. There was a new-looking housing development on one side of the street, and sure enough there was industry on the other side, as promised by the aerials. Parking my car on Clarence, I went around the block counterclockwise, photographing continuously. I went in and out of indented dead-end streets, and eventually I came back to where I had started.

I discovered through some articles in the *LA Weekly* that I had been in gang country, that the Pico-Aliso name refers to two housing projects in the area, that Moon's Market is an important landmark, and that there had been several notable homicides in the last few years. My only protection is that I am often photographing at nine o'clock in the morning on a weekday, when the only people who are out are mothers, schoolchildren, and people who work in the area.

Further study of aerial photographs revealed the housing projects, nearby single-family homes, and more industrial blocks. I found other industrial areas on the east side of the Los Angeles River and decided to visit them all. Again, characteristic of these neighborhoods are the nearby and intermixed residential areas.

So my peregrinations became thematic picaresques. What you see and photograph—on the ground, in the built environment, and in its being rebuilt—are signs of the processes of industrial revolution and repurposing.

The built environment that we now have is an artifact. For Los Angeles, it is an artifact of the Second Industrial Revolution, the successor of the Industrial Revolution of water, mechanical, and steam power. The Second Industrial Revolution was deeply influenced by thermodynamics, and here matters of conservation and flow of materials and energy play a central role. It is a story of processes rather than batches.

That built environment has by now been multiply repurposed. Whether it be water or power or society, of course we can photograph only the visible built environment and infrastructure of Los Angeles.

Industrial Revolutions

The Industrial Revolution—factories, water power, eventually steam engines, textiles, and a bit later railroads—might be said to be less

scientifically based than was a subsequent industrial revolution (say 1870–1925): chemical synthesis and continuous processes (versus batch processes) and chemical engineering (circa 1900); electricity and electrochemistry; thermodynamics applied to engines and to chemistry; and the rise of the automobile.[2]

As for chemistry, there were two major developments. First, the heavy chemical industry developed ways of continuously making sulfuric acid, chlorine bleach, and soda (sodium carbonate), dirty processes that led to what are called "alkali towns." It also developed efficient ways of fixing nitrogen—potash, superphosphate, ammonia (the Solvay, Haber-Bosch processes)—for fertilizer. These chemicals were also needed for textile manufacture and for making soap and glass. Moreover, new processes developed for making iron and steel, as well as electrochemical ones for aluminum. Associated with these transformations was the rise of chemical engineering, generalizing and so teaching the steps in these processes into more general unit processes applicable more widely, while still retaining proprietary specific information to the industrial producers.

The second development concerned synthetic dyestuffs—which led to pharmaceuticals, and more generally organic synthesis, and so to biochemistry. Here the big advance was William Perkin's development of mauve (1856, synthesizing aniline purple) and other dyestuffs, and the rise of industrial chemistry research and the educational system that would produce the people who would staff those research laboratories.

As for electricity and thermodynamics, electricity allowed for the transmission of power over long distances, separating the sources of power from the consumers. Thermodynamics allowed for systematic analysis of all these processes.

Industries such as motion pictures (photography, flexible film base, specialty glasses for lenses), mass agriculture (fertilizer), traction, or the automobile all depended on this second revolution. So did the rise of petroleum as a fuel, and eventually as a feedstock for synthetic organic chemistry (after World War I at the earliest; actually after World War II), and synthetic fibers.

Industrial Neighborhoods and Districts

The introduction of farm machinery and of water and steam power and of automatic powered machinery for mass production led to a reordering of the spaces where people lived. Eventually urbanization became more prevalent, and wage labor in factories became more the norm. In time there evolved a residential fabric intermixed with industrial. As for the Second Industrial Revolution, electrical power allowed for

smaller firms located closer to consumers of their products. Continuous processing allowed for much larger enterprises, whose scale and scope were of a new order.

The Industrial Revolutions led to the dense and complex and articulated cities we now have. The *industrial neighborhood* is a product of the Industrial Revolutions (in Los Angeles, the Second Industrial Revolution), plots and blocks of industry intermixed, sometimes interdigitated, with residential areas for the workers in those factories. The workers could walk or eventually take a streetcar to work. Industrial neighborhoods are heterogeneous, in the design of the various sites and buildings, in the intimacy and relationship of residence and factory: sometimes the factory was there first, and sometimes residences were torn down to make room for a factory; yet the adjacent residences continued to be occupied. Often the external form of factory had little directly to do with its actual internal functioning; buildings were readily adaptable (internally), and new industries often occupied old buildings. What we see is what there was, redone, modified, torn down and built differently, repurposed—a palimpsest.

Industrial neighborhoods are not only heterogeneous and artifactual; they are also quite varied. There is little mass-produced about them (unlike industrial parks composed of tilt-ups). If there were once similarity among buildings, that has been articulated by decades of modification and rebuilding. There are typical blocks and streets, but each block or street is distinctive, not at all average.

Electricity-distributing stations, converting high-voltage electricity and distributing it to users at a lower voltage, are of course products of the Second Industrial Revolution. Storefront churches too are such products. The original stores were often located at what were once streetcar stops (perhaps they were so-called "taxpayer blocks" of stores, strips developed commercially to pay taxes, while awaiting further development opportunities), and often the churches' members (or their grandparents) came to the city to find work in factories and shops.

The historian Greg Hise summarizes our understanding of industrial Los Angeles:

> Industrialization and the rise of the industrial city in America have been understood to be or have been equated solely with large vertically and horizontally integrated firms engaged in mass production. Although Los Angeles has not often been considered an industrial city, it is a particularly rich site for the kind of mixed specialty and export economy scholars have begun to see as the standard model for urbanization from the late nineteenth century to the present. The ongoing relative robustness of the economy and continual cycling through of firms in manufacturing and warehouse/production facilities has meant that the structures and spaces designed and developed from the 1910s forward are still in place and often

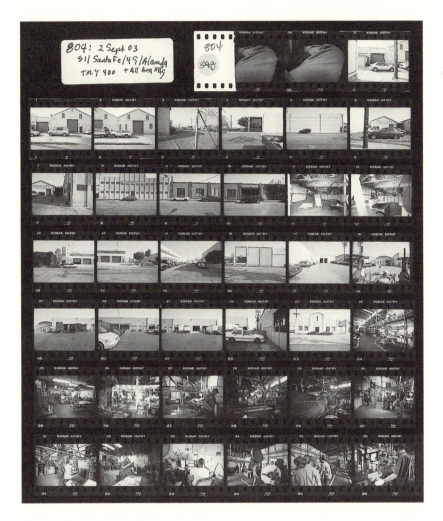

Figure 9. An industrial street (East 51st Street) and workplace in Vernon, California (Figure 1A and B, #10).

still in use. (In New York, Newark, [and] Chicago the loss of manufacturing and disuse or gentrification and adaptive reuse have meant that this landscape has been lost.)[3]

"Functional segregation," in the guise of urban planning and zoning, produced exclusively *industrial districts* (vs. neighborhoods). Still, these districts were sited comparatively close to residential districts—whether because of limited worker mobility, or because of availability of housing,

or both, or because housing was deliberately developed close to these districts. Industrial districts might have agglomerations of similar businesses, or interlinked specialized businesses that fed each other or supplied more general and larger firms, or a changing panoply of firms depending on the needs of the moment. Moreover, firms moved when they had outgrown the space available to them, and those spaces were then available for resettlement by smaller or more marginal firms or industries.[4] This movement of firms enlarged the city into a densely linked metropolitan area.

People continued to live not so far from where they worked or from the locales and sites where many of the manufactured (and agricultural) goods they needed were produced. There was no "far distance," no perspective, from which they might survey either the industrial world *or* the residential world. Those worlds were too close; they were mutually interdigitated and interdependent. The only way people might see the world in which they lived and worked was by in effect employing a wide-angle lens, one that would outdo their angular range of vision by a factor of two, taking it all in. They could not just step outside of their world, dollying back for a more comprehensive view.

Perhaps it is not surprising that the way to photographically document such places is by employing an actual wide-angle lens: getting up close yet seeing more widely; photographing a street site by site along the block; looking down streets and through open bays; entering into factories and warehouses—with looming foregrounds as active and rich in detail as is the allover complexity of the scene. (The usual problem when using a wide-angle lens is that the foreground is uninteresting and bland, perhaps an empty roadway.) Everything must be in focus, for everything counts as it is, as it is seen. Since so much is taken in by the lens, the range of brightness in an indoor scene is as great as can be imagined: the sunshine outdoors or coming through skylights; the corners of the industrial building in comparative darkness; and pools of artificial light illuminating the work areas. The dynamic range of such a scene exceeds the capacity of film or sensor—and so multiple exposures at different levels of sensitivity (another aspectical variation, done automatically by our eyes) may be needed to get it all in. Work and people are wrapped around each other, in space and in psyche and in economy.

Los Angeles

I am not sure if this snapshot account can support a claim that Los Angeles's industrialization is nicely characterized by the Second Industrial Revolution. Rather, it is clear that Los Angeles developed and

industrialized much later than most other currently dominant American cities, and chemistry and thermodynamics and electricity were available to be exploited at just these times, with comparatively little past infrastructure around that needed to be superseded.

Specialty chemicals were now widely available, and factories could readily obtain the stocks (of chemicals, materials) they needed for their processes. Smaller firms might be located for purposes of transportation and the availability of labor, rather than for the availability of power or raw materials and feedstocks. Warehouses allowed for distribution systems. Agriculture became a chemically driven industry with enormous rises in productivity. Railroads, and eventually truck transportation, allowed for more deliberate relocation for efficiency purposes, and hence one had a more fluid urban economy, in effect enacting Adam Smith's Invisible Hand with alacrity.

Los Angeles's location in the western part of the United States meant that some of its industries were protected from distant competition. Its distinctive climate and agriculture meant that some industries were especially suited to the Southern California locale. But, in general, we might expect that the generic forces of the Second Industrial Revolution operated here. Los Angeles is now a cumulative layering of earlier artifacts and built environments, as well as the much more recent influences of information, aviation, and entertainment.

Los Angeles is now a leading industrial center in the United States. The region is fabulously renowned for its dispersed residential fabric (although, in fact, other major cities are more dispersed) but little recognized for its less than glamorous industries interwoven with those residential areas. "Industry" is a very broad classification, and it includes resources, services, construction, manufacturing, agriculture, mining, transportation and goods movement, and communication. More specifically, for Los Angeles it surely includes aircraft, aerospace, entertainment, the port, petroleum extraction and refining, clothing, computers and tools and scientific instruments, furniture, rubber and plastics, chemicals, fabricated metal products and iron and steel, and printing and publishing. On the streets some industries look generic, housed in large rectangular boxes—especially in industrial parks and industrial cities. Other industries look quite specific, with tanks and pipes and smokestacks, or with large uncovered piles of sand or garbage or scrap. The detail and complexity, seen from the street and through open doors, demand a knowledge of industrial processes if they are to be understood.

Los Angeles has had a rapid and intense development of its infrastructure. For reasons of speed and pride, that infrastructure has not always or even often been buried or hidden behind gates. It has been

celebrated and monumentalized. Whether it be its waterways or its storefront churches, its electricity-distribution system or its built industrial environments, that infrastructure is intimately available to the everyday life of Los Angeles's residents—were they to travel outside their well-worn patterns. The City is an inhabited archaeological site, its past activities still visible, readily unearthed, casually turned up in everyday contemporary processes. Topography and materiality have not been built over by construction or ideas.

Repurposing

To reiterate, an industrial neighborhood is a region of a city that has substantial amounts of manufacturing, warehouse, construction, or transport industry and that has as well a substantial residential component—either intermixed with the industrial or intimately adjacent to it. Residents, within the neighborhood or adjacent to it, often work within the neighborhood, or there has been a long period when that was the case. So, for example, the manager of a downtown Los Angeles electrical equipment company points out that many of his employees live a mile or two south.

A characteristic feature of industrial neighborhoods is the *repurposing* of the built environment. Whatever the original enterprise that occupied a building, over time that enterprise may succeed so well that it needs to move to outlying areas with more available land or it may fail.[5] New and different and presumably smaller enterprises now occupy the building. A postal facility moves to new quarters, and a wiping-rag firm moves in. Add-ons are enlarged; structures are reinforced after an earthquake; buildings are combined or perhaps segmented. The system of industrial buildings and land is a resource, to be employed in new ways as technologies and economies change. What was once purpose built is now repurposed, again and again. The comparatively nearby or intermingled residential area is a resource for labor, for neighbors relatively tolerant of noise and pollution or who are incapable of protesting these hazards, and for land that might be employed for industry.

The term "repurposing" would seem to come from "content repurposing" as used in the media industry: taking a movie and making it into a videotape, and then into a DVD, and then into a videogame. "Adaptive reuse" is the term of art when a church or factory or school is converted, for example, into condominium residences. Economically, in terms of real estate, one might say that all that is happening in repurposing is that, for example, stock for industry is being adapted for new tenants, or that new owners are adapting their buildings for their own purposes.

What is interesting is just that recurrent adaptability, as well as those left-behind artifacts or vestiges of the past—say, ventilation shafts for methane from horse droppings, the horses having been used to haul ice through the streets of Los Angeles.

The continually repurposed buildings form a layering of past uses. The same is true of the residential stock and nearby labor force, so there is as well a layering or palimpsest of past residents. In Los Angeles there are substantial flows of immigrants (from the South and Midwest of the United States, from Asia and Latin America), often people of color, who may settle in these neighborhoods, close to available less-skilled jobs; and as their prospects improve they too move away, so making room for newer immigrants. Along the way, at least in Los Angeles, motion pictures may be shot in unoccupied factories or in warehouses temporarily used as movie sets. Hence, there is a good chance that the neighborhood and its distinctive buildings, both inside and out, are immortalized in movies.

Crucially, the structures in these neighborhoods last much longer than their planned lifetimes. Even earthquakes do not make them unusable and one can see the square metal ends, attached to the reinforcement rods, on the outsides of the otherwise unreinforced buildings. Moreover, fire does not destroy the four-foot-thick walls of an ice plant, so the building might endure. Rents are comparatively low since the buildings are old, the homes are somewhat dilapidated, and there is the always-possible prospect of neighborhood renewal so that long-term leases are precluded. Railroad spurs may run through the blocks, electricity substations may well be nearby, and freeways may also be nearby. The railroad and electrical facilities were parts of the formation of these neighborhoods; the freeways could be located in these areas since there was less resistance to the clearance that was needed.

Interestingly, much earlier immigrants might well have once lived in these eventually industrial areas, their land and homes destroyed in a subsequent phase of industrial development. But the next waves of immigrants reoccupy the neighborhood the best they can, both as workers in the factories and as residents. Each wave of immigrants has its own distinct qualities, so that the earlier Hispanics may have come from northern Mexico, while the current waves come from Central America. What is crucial, in each case, is that they are recent immigrants, willing to work for less, and they accept a lower standard of living, at least for the moment. They make up the lower working class of their times.

Downgrading has served these neighborhoods well (if not always the well-being of their residents). Commercial strips adjacent to streetcar stops are less valuable than they once were (no streetcars, fewer bus riders), and abandoned stores become storefront churches or start-up locations for businesses.

This is the world of low rent and high risk. It is also the world that most people drive by or never even see except from a freeway or from an airplane as it is landing. Again, motion picture location scouts know these industrial neighborhoods very well. They are perfect places to shoot a movie in the middle of the night or a movie that has loud and unpleasant special effects.

While there is much talk about creative space and the high-tech economy, most of the enterprises in these industrial neighborhoods reflect the Second Industrial Revolution of electricity, chemicals, and the automobile. In addition, what is moved here is material, mostly by truck, rather than bits and bytes moved along optical fiber.

The major challenge to the ecology of the industrial neighborhood is upgrading and functional segregation. More stringent zoning and environmental codes, or more stringent enforcement, will make the building stock substandard, the industrial processes polluting, the convenient access to jobs more strenuous. Residential lofts and improved housing will displace and chase out industry, jobs, and less-advantaged residents.

Such is the story or identity that accommodates the streets I have surveyed, the workers and industries I have documented, the neighborhoods I have walked through. The work of historians, economists, and geographers provides the material to tell such a story. But it is the survey, the documents and images, and the experiences that make such a story cogent, for the story provides for the aspects we encounter, that manifold presentation of profiles.

Chapter 3
Choreographies of Work

A choreography of work describes how people work together in a co-ordinated, predictable way in actual environments. That choreography is defined by proprietors or managers and perhaps by industrial engineers, and then is refined by the workers themselves. After a brief introduction to more general issues, the focus will be on Los Angeles's industry (the ports, manufacturing, merchandising) and then a discussion of some of the problems involved in understanding a choreography through images.

In the *Preliminary Discourse* (1751) to *L'Encyclopédie*, d'Alembert recommends that we "go directly to the workers" if we want to understand the processes of manufacture, since there is "ignorance concerning most of the objects in this life," and "from that problem is born the need for figures [illustrations]." He further writes, "It is workmanship that makes the artisan and it is not in books at all that one can learn to work by hand."[1] If you want to understand people's work, you have to go out and look, and watch, and ask questions. That is just what Diderot did as he tried to describe the arts of his day.

There is still room for Diderot's enterprise nowadays. Most of us have seen little of the industrial processes that allow for our urban lives; photographic documentation rarely attends to it. Engineers design machinery to make things, and skilled work is studied by other engineers and computer scientists in order to make better mechanical equivalents. But that knowledge, not to speak of the look of the workplace, is rarely documented in detail more publicly. It is the occasion for spectacular photography (Lewis Hine, Lee Friedlander), but not for systematic documentation.[2]

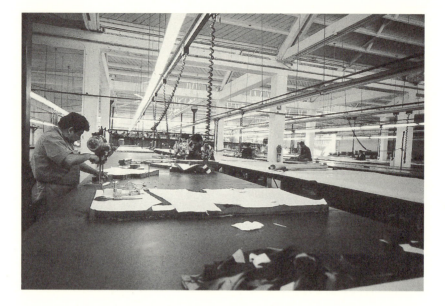

Figure 10A. Workplaces in Los Angeles: cutting fabric (Figure 1C, "f").

Picturing Workplaces

> *Uncovering a history of production and industry in Los Angeles requires the reconstruction of a landscape that was largely invisible to contemporaries and that has remained almost invisible up to the present.*[3]

Los Angeles is one of the industrial centers of the United States in the twenty-first century, much as Paris was the center of French industry in the middle of the eighteenth century, although some specific industries such as porcelain and tapestry were located elsewhere. Much of Los Angeles's industry, especially manufacturing, is comparatively small-scale, in repurposed buildings, an accumulation and filtering down of the past history of the region's industrialization. While many of us may have glimpsed the industrial areas of Los Angeles—driving by or as sets and backgrounds in motion pictures—unless we work in the areas, they are rarely seen up close and in person, and then they are seen as industrial areas that are fully productive—work and people wrapped around each other—rather than as rough and dangerous neighborhoods.

The indoor landscape of these factories, warehouses, and shops reveals the industrial processes of wood, metal, cloth, and chemicals, none

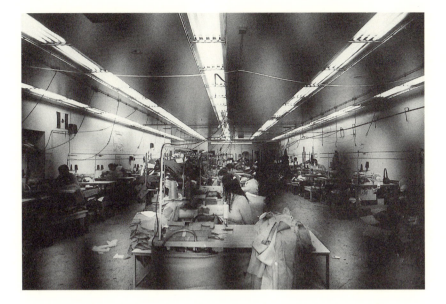

Figure 10B. Workplaces in Los Angeles: sewing garments (Figure 1C, "g").

of which is postindustrial or information processing. They are material. Moreover, these materials have to be transported among processors and markets, and hence goods movement (or materials flows) is a major component of manufacturing and industrial work. So we are fascinated by the Ports of Los Angeles and Long Beach and by the Alameda Rail Corridor that links downtown Los Angeles to the ports, as well as by the truck-filled 710 Freeway.

Visiting many workplaces, you may sometimes find a familylike atmosphere, the workers informally interacting in a friendly and patterned way. In addition there is a culture of the workplace that is not so mechanical as is often ascribed. Actually there are many such cultures. And yes, there are workplaces that are much more fragmented, people listening to their Walkmans or iPods while sewing, rarely looking at each other. But even there they have to give work to each other, and so workers had better do their jobs so the people down the line can do theirs. Also during breaks and lunch they do talk, extending those snippets of conversation shared while they were doing their work.

How might images depict either a familylike atmosphere or teamwork? If you know what has to be done (think here of a basketball team), then you can discern from the moves of the players how they act (or do not act) as a team. But if you do not know the larger task to be accomplished,

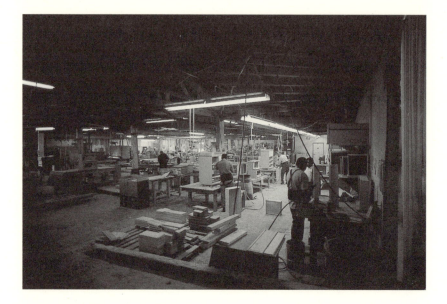

Figure 10C. Workplaces in Los Angeles: making furniture and cabinetry (Figure 1C, "h").

you will not so readily discern it from the various moves. In that sense, the choreography depends on one discerning or imagining a larger task, watching what people do (a dance), and modifying one's imagination of what that task is, so that eventually you can see the work (or the worship, in the case of churches) as a meaningful dance. You then understand the choreography. Again, there is an accommodating identity in a manifold presentation of profiles or aspects.

Some Industrial Geography of Los Angeles

In the City of Los Angeles the main manufacturing industries are apparel, transportation equipment, electronics, fabricated metals, printing and publishing, and food. About two-fifths of the apparel workers are sewing machine operators. Others operate dye machines or knitting and weaving machines, or are hand sewers and pattern makers. Yet apparel is dwarfed as an industry by construction, warehousing, and goods movement.

It is a truism of industrial geography that industry is spatially concentrated, and particular industries tend to be close to each other. The City of Los Angeles divides its industrial concentrations into six areas: West

Valley, North Valley, Central Valley, West Los Angeles, Metro Los Angeles, and Harbor. Each area is nicely delineated by railroad lines, reflecting the past and to some extent the present of goods movement in Los Angeles and of industrial zoning. Recall the district defined by Slauson Avenue, Central Avenue, Florence Avenue, and Avalon Boulevard (Figure 1A and B, #1; Figure 1C). It was threaded through by railroad lines and spurs coming off Slauson, and it developed from the 1920s on as an industrial tract. In time it was surrounded by residential development and so connected employment opportunities with where people lived.

As for particular industries, the Furniture and Decorative Arts district in the Downtown Metro/South Los Angeles district extends as far south as Florence Avenue with Central Avenue on the east, although there is important furniture manufacturing in other areas. Now everyone will tell you that most such manufacturing is shifting to China and India. Still, even if furniture is a small part of manufacturing in Los Angeles, there is lots to see as you survey an area.

Metal fabrication and finishing is another small part of manufacturing in Los Angeles. It too is concentrated in a number of neighborhoods and areas. Yet metal-finishing and metal-plating shops can be found in the most remarkable places, often nearby residential or commercial districts. These shops display their diamond-shaped blue-red-yellow-white signs: left, top, right, bottom, respectively, of health threat, flammability, chemical reactivity, and specific hazards, such as *C* for *Corrosive*. For blue, red, and yellow, the scale is from 0 (no problem) to 4 (deadly, explosive). Like the cloth and wood industries, the metal industries are linked in a network of suppliers and manufacturers, and so warehouses, metal-fabrication, and metal-finishing firms are often not far from each other. The metal trades include machinists, tool-and-die makers, and welders.

There are major lacunae in my documentation, despite having photographed at more than 225 sites: in particular, very large manufacturing and aerospace sites, and motion picture studios. In each case permission to photograph and access was much more difficult if impossible. Often I did not have the right connections. However, some of the time I did, as in the Ports of Los Angeles and Long Beach, and at the Los Angeles County General Hospital. In addition there were many categories of industry, such as office or financial work, that I did not include in my project.

The Port: Infrastructure as a Choreography of Machinery, People, and Goods

Historically, and still today, one of the vital systems for cities has been waterways, lakes and oceans, the fishing and whaling fleets, and the merchant marine that moves goods and people from place to place.[4] The history of

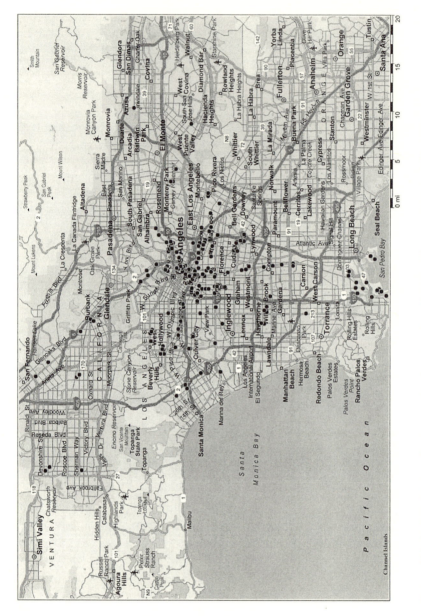

Figure 11A. Industrial sites documented in Los Angeles. Map used by permission of Microsoft.

Figure 11B. Industrial sites documented in Los Angeles (detail). Map used by permission of Microsoft.

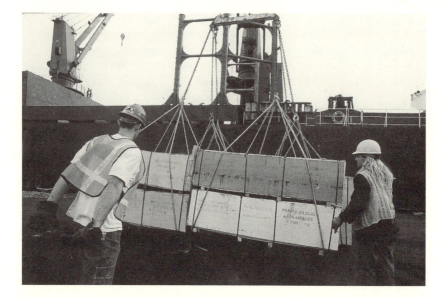

Figure 12A. Longshore workers: frontmen unhooking cargo (plywood from Malaysia) (Figure 1A, #6).

the West Coast's International Longshore and Warehouse Union (ILWU; here think of Harry Bridges, its fabled leader) and the Pacific Maritime Association, and their current events, are of international import. As I have been told again and again, the Ports of Los Angeles and Long Beach (Figure 1A, #6) move about two-fifths of the cargo and an even greater percentage of the containerized cargo in the United States.

Most of the women and men who work at the ports are members of the ILWU, stevedores working on the docks of the Ports of Los Angeles and Long Beach: Local 13 of Longshoremen (including the frontmen, UTR (utility truck) drivers, forklift operators, lashers, linesmen, and spotters); Local 63 of Marine Clerks; and, Local 94 of Foremen or Supervisors of Longshoremen. Some are supervisory personnel (superintendents) from the shipping or stevedoring companies or are shipping agents. At the docks it is essential that the supercargo (the in-charge person from Local 63) and the supervisor or superintendent work together closely to be sure that the ship is properly unloaded and loaded. The dance is a complicated one, since an improperly loaded ship will be subject to shifting and imbalance, or the unloading might take much longer and be more inefficient than would otherwise be the case. Years of experience (especially of the longshoremen), careful coordination,

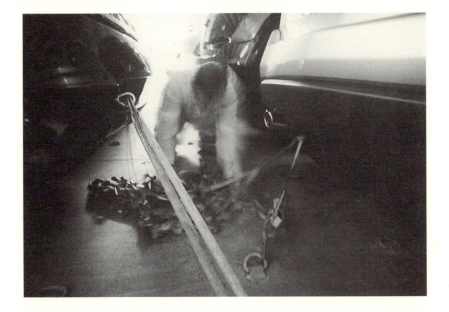

Figure 12B. Longshore workers: unlashing automobiles from Japan so they can be driven off a ship (Figure 1A, #6).

and modern information systems make the difference. Moreover, the right number of men and women and the right sort of loading and unloading equipment must be present at the right time. In part this is coordinated by the Marine Exchange, which keeps track of ships entering and leaving the ports, and the shipping agents and stevedoring companies. In part the ILWU Dispatching Hall makes sure the people are at the right place at the right time.

I photographed at a break-bulk ship (for example, large coils of cable); a refrigerated fresh-fruit ship (from Chile); a container ship; a roll-on roll-off ship (RO-RO), on which the cargo (for example, earth movers) is unloaded under its own power or with forklifts; a bulk loader (for example, carrying petroleum coke, a derivative of refining in the Southern California region, a black powder pumped onto the ship into large holds); an automobile ship (holding perhaps six thousand Nissan cars and trucks); and a cruise liner (the baggage's location is coded by animation characters). I also photographed at the Marine Exchange and the ILWU Dispatch Hall. In addition I photographed some of the systems of rail and drayage (trucks), which are the means of moving goods to and from the ports to the hinterlands. Nowadays they represent particularly significant links in the larger networks.

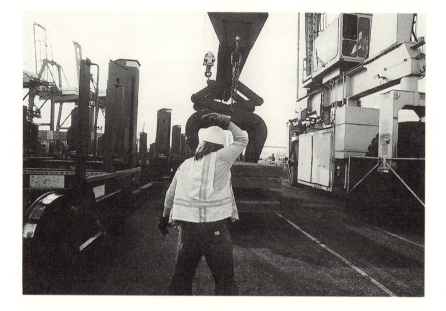

Figure 12C. Longshore workers: guiding a crane (Figure 1A, #6).

Infrastructure is not merely copper or aluminum cable, or glass fiber, or bridges and roads, or concrete pipes and pumping stations, or electricity-generating stations, or the systems of these parts that form the lifeblood of cities. It is also the people who build, maintain, and operate these systems, and the stuff that is moved along their pathways. These coordinated objects and motions and people—and they must be coordinated if such systems are to work well and not fail due to congestion or breakdown—in effect enact a dance whose choreography is what interests me. What we see in these photographs of people at work is an answer to the children's question, Mommy, Daddy, what do you do all day at work? One answer is, I work with other people to get the work done. That choreography is one of the great dances of modern society.

Indoor Landscapes of Los Angeles Work Sites

Things are made by people using tools and machines, in places called workshops or factories, often located in industrial districts and neighborhoods. Ordinarily we do not see these manufactures in action, at best being aware of them by noise, smoke, and traffic; the snack wagons and lunch trucks that appear like clockwork; the workers clustering

around the wagons and trucks outside the factory on their breaks; and the workers going to and from their jobs. Still, we can walk the streets of most industrial neighborhoods; often enough even industrial districts are adjacent to residential areas and are quite accessible. In Southern California a mild climate and good weather allow for many open bays and windows, so one may see what is going on inside without being invited in. Sometimes I am invited in to talk, and to look, and to photograph. For landscapes of labor and production, I have focused on unobtrusive photographing of people at work in smaller light-industrial firms housed in repurposed buildings, rather than on formal compositions of larger heavy industries in purpose-built structures.

A characteristic feature of landscapes, as images, is that most of the people in them are shown as comparatively small, so you can just figure out what they are doing, the details of their physiognomy marginally available.[5] The lighting may be fairly uniform, but sometimes it is variegated, clouds and shadows allowing for vastly different luminances on the ground. Correspondingly, in a factory lighting is often local and specific to each process, with overall light coming from skylights. Such indoor landscapes show the scene of production: a building filled with machinery, materials, people, and social organization. The documentary and the landscape traditions are combined.

Early industrial photographs often showed workers posing, sometimes proudly, with their products and processes and machines. But here people just go about their work. My photographs were taken with a wide-angle lens, usually comparatively close in, with permission asked. (The wide-angle lens, close in, can allow for both documentary detail and landscape overview.) People are aware that I am photographing. Still, they continue doing their work. That is their job.

Here industrial photography shows what people do and where they do it, as part of a system or a collective enterprise. I want to show what is there, what is ordinary, repeated in varied particular ways in the factories and industrial sites of Los Angeles. If you were to listen to the working people speaking, you would hear Spanish as the lingua franca. There is a long tradition of Spanish-speaking residents (namely, Mexican Americans) in many of these areas.

Consider, for example, some of the firms I visited initially: all are comparatively small firms in older repurposed buildings, whether they be warehouses, shops, or factories. At Valerie Trading (Figure 1A and B, #1; Figure 1C, "b"; Figure 13) each day workers sort thousand-pound bales of used clothing collected by charities. Eventually this clothing is sold in more specialized lots to suit the needs of particular buyers (from high fashion to poor countries). At Farmhouse Furniture (Figure 1A and B, #1; Figure 1C, near "c") a distinctive line of furniture is made. At Plastopan

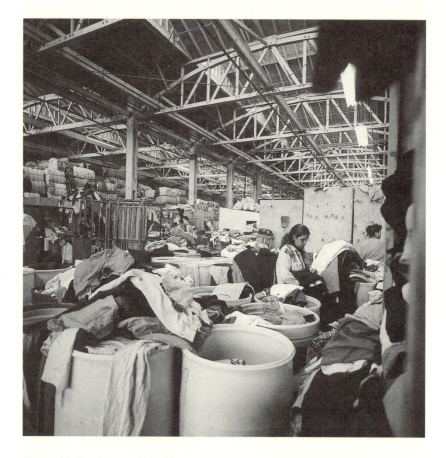

Figure 13. Sorting used clothing; thousand-pound bales in the background
(Figure 1A and B, #1; Figure 1C, "b").

(Figure 1A and B, #1; Figure 1C, "a") workers make the plastic contain-
ers used for to-be-shredded documents (and hence the containers have
locks on them). At an unlabeled one-room workshop, the workmen make
chairs and other finely turned wooden items (Figure 1A and B, #1; Fig-
ure 1C, "c"; Figure 14). At All American Manufacturing (Figure 1A and
B, #10; Figure 9) out of metal workers make whatever you need.

Often the things that are manufactured or distributed are sold lo-
cally, especially if the business is small and caters to the particular needs
of each customer (caskets, machined parts). In some cases the busi-
nesses are part of informal networks of coordinated firms that process
intermediary products for each other, and they are relatively close by
each other, as are cutting and sewing in apparel manufacturing. Such

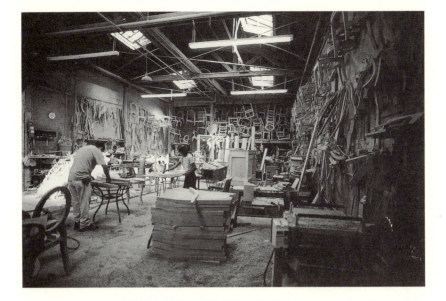

Figure 14. Making chairs at a one-room workshop (Figure 1C, "c").

businesses may well have sufficient past assets and savings (again, older repurposed buildings, machinery, land, skilled labor, networks of customers and suppliers) and sufficiently specific market niches, so that they thrive even when they are apparently not economic and ought to be replaced by offshore lower-cost manufacturers whose costs of transportation remain modest. Some businesses, such as auto repair and body shops and auto-glass shops, are apparently, at least for now, inherently local. There will be surprises for the economist or the globalizer, since some modes of production may continue well after they ought to have been replaced by distant lower-cost businesses or efficient mass production. Generic historical and economic forces and equilibria are often defied by specific facts, locales, and markets, and by lags in the equilibrating process.

Again, for the most part I photographed work that is not office work or pink-collar work or service work, or part of the information economy.[6] Rather, it is a material culture, where by "material" I mean wood, cloth, metal, oil and chemicals, railroads, trucks, and so forth. In such a material culture, everything is made somewhere out of things from somewhere (else), used someplace, and disposed of elsewhere, and perhaps recycled—and transported between those places.

Exceptionally, I was privileged to photograph people at work at the

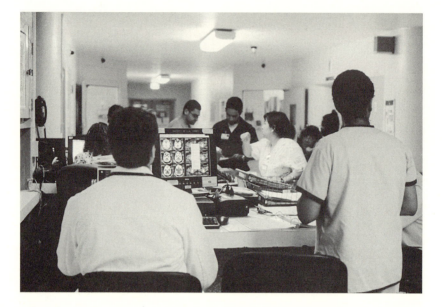

Figure 15. Staff at work at a nursing station, Los Angeles County–University of Southern California General Hospital (Figure 1A and B, #5).

Los Angeles County–University of Southern California General Hospital (Figure 1A and B, #5) a few years before it was replaced by a new facility. Again, what was striking was how people worked together, as a family, to make the place function—where the crucial "home" was the nursing station. The formal hierarchy had to be flexible enough to deal with contingencies. Intense moments demanded coordination. People had to work together.

All this work would seem to involve craftsmanship and skill and devotion, even if some of the work is called menial or unskilled. The work may not always be interesting or deeply satisfying, but if it is to be done properly, the workers must be committed to the craft, even if they are just making a living.

Merchandising

The formal governmental definition of "industry" includes retail establishments. The storefront houses of worship I discuss in Chapter 5 are often located in commercial strips, sometimes adjacent to ethnic markets. So I looked into those markets, struck by the arrangement of

Figure 16A. Entrance to two ethnic markets in Los Angeles. (See also Figure 16B).

the displayed merchandise, what is called "visual merchandising." For different ethnicities, the goods are identifiably different and particular. But I noticed as well the orange boxes of Tide detergent, a universal sign in the midst of particularity and specificity.

Such visual merchandising is a discipline in itself, its purpose being to arrange goods so that they are more likely to be sold. For these small businesses, there are no professional store designers, and except for manufacturer-shipped displays, the arrangements are vernacular rather than professional ("vernacular" meaning ordinary, nonexpert, nonprofessional, to some extent idiosyncratic). However, the vernacular may be influenced by mass media, advertising, and fine art such as still lifes.

Of course, the bazaar and the marketplace were places to display one's wares, and so the vernacular version of this discipline is very ancient indeed. With the rise of urbanization, commercial agriculture,

Figure 16B. Entrance to another ethnic market in Los Angeles.

and mass production, a consumer culture arose, and brands became a way of distinguishing similar merchandise (as contrasted to the names of the growers or craftsmen). Moreover, promenading and shopping became intertwined, and the display of merchandise in store windows was intrinsic to marketing. (The stores' plate-glass fronts date back to the seventeenth and eighteenth centuries. The mechanized manufacture of plate glass began in the nineteenth century. See also Figure 7.) Electrical lighting enhanced these possibilities. Advertising, the mass illustrated newspaper press, and catalog merchandising further solidified the visual and mass character of merchandising.

But close up, mass becomes multiply subdivided. Los Angeles is an

ethnic society, the variety of ethnicities being very large, often changing, and divided and divided again into smaller groups. These groups are sometimes geographically concentrated, but even then several groups are likely to live intermixed with each other in their neighborhood or community. Ethnically specific stores may well have substantial patronage from people of other ethnicities in the neighborhood, and mainline stores may have ethnic sections. In addition, despite all the newspaper articles, it would appear that most people live together in a neighborly way, acutely aware of the differences between groups but also respectful of their neighbors.

There is a long tradition of photographs of small businesses and their owners. In the first decades of the twentieth century, Atget photographed the outsides (and the in-front-of-the-store displays, the *étalages*) and the just-insides of stores in Paris as part of a larger project documenting ordinary life in the city and its suburbs. Subsequently, Berenice Abbott (1898–1991) and Walker Evans (1903–75) pursued Atget's project in the United States, producing some of the signature photographs of modern photography. August Sander's (1876–1964) People of the Twentieth Century project attempted to catalog the varieties of Weimar-Germany society: the Farmer, the Skilled Tradesman, the Woman, Classes and Professions, the Artists, the City, the Last People (homeless persons, veterans). Many of these people were businessmen and workers.

Atget documented the beginnings of a consumer society, and Abbott and Evans photographed that society as it flowered yet retained a quaintness of earlier times. Sander's images are meant to be archetypal of the societal transformation he was witnessing. My early twenty-first-century photographs are in effect throwbacks or vestiges.

Choreographies of Worship and Work

Recall that the work people do together might be described as a *dance* of production. How the work or the dance works, its meaning and how it is continually set up to work, is the *choreography*.[7] (So a description of a NASCAR race said: "Amazingly, a crew of seven people, in a highly choreographed routine, can change four tires and fill the gas tank in less than 30 seconds."[8]) The following describes religious worship (previewing Chapter 5) and then working in apparel production.

Although I have many images and videos of people at worship and at work, I have not included any for the particular sites I shall now describe. It is too easy, at least for me, to tell myself that I see in one image or one video clip the choreography I am describing. Only with many

images, and perhaps with fieldwork as well, can you actually see it, appreciate that identity. The single document is too much a temptation, or so I believe.

Putting Ourselves in Place

Worship at a church, as a whole, is a dance. Surely individuals are performing their own parts in the dance, but worship is congregational. People work with others to produce religious worship. There is a choreography of worship.

Just as in basketball, where *the players put themselves in the right places* relative to each other and the court—each of them, for the next move, and then do so again and again—so that they can play basketball (rather than be klutzes or not know the meaning and purpose of the moves of the other members of their team), so in worship the congregation, the minister, and others put themselves in the right places (body attitude, tone of voice, dress, and so forth) so that they can engage in worship. These activities are inherently social, people aware of themselves and each other and their purposes, and they work together so that they then can go about the business of whatever it is they are doing: worshipping.

What are the (pre)patterns of engagement of people with each other, what do they do among each other so that they have a sacred place in which to worship? Surely it is a matter of their intentions, their desire for worship being deliberate, or perhaps it is tentative, not being sure this is the place for them. In part it may be a matter of how they dress before leaving their homes and their decorating their worship space days ahead of time. It is as well how they arrange themselves, how they bring music, family, Bibles, and hymnals all to bear. It is the gentleman or lady at the door who brings in newcomers, screens out problems, welcomes regulars. It is the crew members in the back of the room who are checking things out.

There are more interactional and intentional moves: the back-and-forth response among worshippers and ministers and leaders (some of whom are up at the altar); the subtle control of outbursts and out-of-order expressions. It is as well the children who behave but not quite, or who fall asleep. People are working together so that everyone knows what they must do at each point. People imitate or follow each other (figuring out *whom* to follow), so that that experience is made authentic, rather than an acting out of a ritual.

This is shown, evidenced, to all who are present, demonstrating both the conformation of the congregation and the conformation of individuals (who lead, who follow, who go off on their own), so that they are in a worship service rather than, say, a meeting.

As you better figure out what it is people are up to congregationally and individually, the videos of that worship then show these things more adequately. You are picturing authentic worship, when you have better figured out that identity in the manifold presentations of profiles, although of course you start out almost surely recognizing that this is worship. But so much more is going on, you have to figure it out more deeply. Then it all makes more subtle sense.

Factory Work

Much the same occurs in a large high-end jeans factory (Figure 1A, #15). As for the dance, everyone does his or her part (literally, part of the garment): the garment moves among the workers until it leaves the factory. The workers sometimes talk to each other or listen to their radios or music players (although if they are distressing jeans with chemicals and wire brushes, they are covered by protective gear and masks, and so they are isolated). What makes the factory work? What allows for the choreography? Workers are committed to the factory even if they have simple, isolated jobs, for if their parts are not done properly, the next worker will have trouble doing what they have to do with the garments.

However, this is too simple. Yes, people work hard, and they are committed to their fellow workers.[9] More deliberately, managers recruit people for the factory who bring to the factory values, in action, that make it possible for the factory to produces jeans. (This is sometimes called "work ethic.") Often these are relatives or co-nationals of those who already work there. How are values displayed in action? The answer is, by the workings of the factory, by its choreography. And the photographs, the visual material, your actual experience of the place, make sense once you allow for such a culture and choreography. Otherwise there is no adequate identity. Actually, rather, there is an identity: alienation and mechanical life. But given my fieldwork and experience, I would argue that that is only a sign of the failure of our imaginative draftsmanship.

As another point of reference, the men in a small dye house (Figure 1A and B, #16), who are dyeing trims, stand around hot pots of color, stirring, talking, doing it just right. They have a social life above the pots, literally above, that still allows them to pay attention to the colors and the trims. Their social life is different from that of the women who are in another room two stores north, where the dyed trims dry (by fans) and are then wound onto spools. Here it is quiet, cooler, sparer—domestic. No one is making jokes or fooling around. The men and the women are creating environments in which it is possible and all right to do their work. And, crucially, the work gets done. That is, there is both

the choreography and the dance—the production process (or the work) and the human interaction that make the work possible.

Wide Angle

Wide-angle perspective exemplifies the interplay of the choreography and the dance. "[We are] photographing groups of persons that are engaged in a common activity. Photographed from a close position and center location, . . . the spectator feels to be in the middle of the action. Almost tactile closeness to the subject, combined with the sense of extended depth . . . a picturesque perspective. . . . [In] landscape paintings and paintings of groups of persons, you will notice that there is at the same time a sense of vastness because of depth illusion and wide angle perspective, but also a sense of intimacy as the major objects are positioned very close to the viewer."[10]

In terms of actual photographic practice, the advice usually given is that with a wide-angle lens you need to get quite close to the main subject. You will get a pushing forward of that subject and a pulling back of the background. There will be lots of (now comparatively small) details in the background, and you want them to be crisply rendered.[11] (See Figure 10A and B.)

A wide-angle lens allows us to have intimate detail be present in the context of the whole process of production. That intimate detail is emphasized by its being in the foreground, the process of production literally encompassing the intimate detail or intimate action—the meaning of the detail drawn from the visual context and from the implied intentions of the worker. The wide-angle lens allows both the detail and the totality (sacrificing the middle range and the detail in the totality).

Any sacrifice of the middle range might be made up for by a very fine lens and the right sort of film, so that if you are curious about a detail, you could enlarge that part of the image (or use a magnifying loupe) and see more—implying that there are reserves of information on the film.[12] You need lenses that do a fine job in the outer field of the image so that when you enlarge a corner of the image—to examine a curiosity that had not been anticipated (for if it were anticipated then what is in that corner of the image would likely have been at the center of another image, the center of the image usually being the lens's best performing region)—there is enough residual definition and then some.

Showing What Is Off-the-Record

We want to show the dance as an allover choreography, an intentional teamwork. You can readily show the details of the worship or the work,

the dance. Multiple aspects begin to get at the choreography. But you have to capture the off moments, the mismatches, when something goes awry: the side work people do to make it possible for them to do the ostensible work they are doing—that is, what people do to set up and repair the (social) situation so that they can produce whatever is being produced. Then the dance fulfills the choreography. Some of the work is following the rules, some is having appropriate intentions, but much of it is compensating and repair work. The challenge is to show how people go to the edge, but not too far over it, and so still produce what they are in the business of doing. In the end, you have to imagine that identity sufficiently robustly, that choreography, so that the photographs are now seen as showing both the work and the choreography.[13]

System and Network, Node and Link

Creating infrastructure is a primary tool that states have used to link space into territory, and that territory is delineated by actual infrastructural systems and networks.[1] The notions of system and network are often used metaphorically, to describe societal and natural and physical phenomena. Within broad swaths of Los Angeles, storefront houses of worship form an almost ubiquitous, albeit implicit network. But some of the time what we really do have is a complex unity, an actual system, deliberately designed and built, and more particularly, coordinated nodes and links that work as a whole, a network. Moreover, you can literally see the nodes, for example the electricity-distributing stations for the City of Los Angeles Department of Water and Power system, and you can literally see the links, whether they be overhead high-voltage power lines, roadways and freeways, or concrete-lined rivers and storm drains. Urban tomography, for example visiting and photographing all nodes of a particular sort, allows us to appreciate a network concretely.

Nodes: The Los Angeles Department of Water and Power Electrical Stations

The system and network of the City of Los Angeles Department of Water and Power (DWP) electricity-distributing stations are explicit, centrally planned, and of wide coverage. In the first part of the twentieth century, and subsequently, the City acquired and built up a coherent system of electrical power under the auspices of municipal ownership, along the way acquiring the distribution facilities of earlier private companies, buying out the last holdouts in 1937. Since nowadays electrical power

Figure 17. Los Angeles Department of Water and Power electricity-distributing station (DS 43) on West Pico Boulevard (Figure 1A and B, #13).

is generated far from where it is consumed, there are places where its high transmission voltage must be made suitable for its everyday use. Of good engineering practice, stations receiving electricity from high-voltage transmission lines and sending it at lower voltages to other stations that distribute that electricity at even lower voltages to most users—all these stations—are located more or less uniformly throughout the city. Since they were built at different times, as the city developed, we have an archive of architecture and urban development.

Initially electricity was generated not far from where it was used to light streets, businesses, and some homes and to power industry. In time economies of scale, improvements in the capacity to transmit electrical

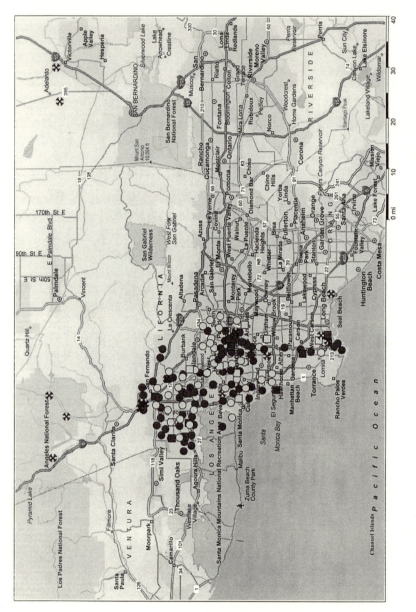

Figure 18A. Electricity receiving (squares), generating and switching (crosses), and distributing (circles) facilities, Los Angeles Department of Water and Power. Facilities by year of construction: lighter marker, before 1960; darker, since 1960. Map used by permission of Microsoft.

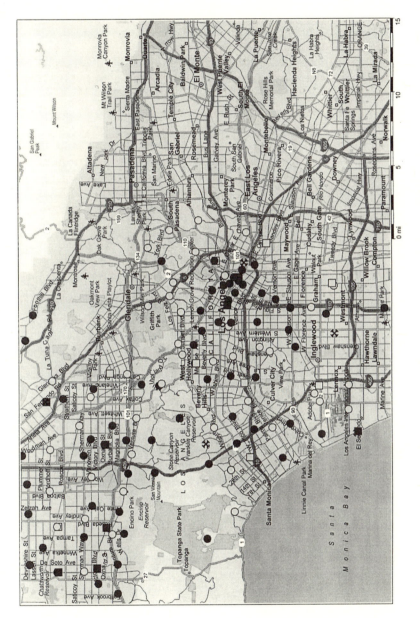

Figure 18B. Electricity receiving, generating and switching, and distributing facilities, Los Angeles Department of Water and Power (detail). Map used by permission of Microsoft.

energy over long distances at high voltages, and so the possibility of generating electricity close to energy sources (coal, hydropower) led to the separation of generation and consumption. That high-voltage transmission electricity needed to be received from elsewhere, converted to lower voltages, and distributed locally to users. Within three or four decades of the introduction of electric lighting in cities, there was a network of electricity-receiving and -distributing stations throughout the city.

A complex and sophisticated and mostly hidden technology allows us to treat electricity as a utility. But that technology has also produced signs of its presence: in transmission towers and overhead wires and insulators, and in the urban buildings that contained the transformers that converted electricity to lower voltages. Rather than through buried cables and conduits, in Los Angeles much of the everyday transmission of electricity is through overhead lines, often located down the spine of each block. There are as well extensive rights-of-way for transmission-line arrays ("corridors," in effect an electricity freeway) cutting across the region. Just underneath these arrays is a variety of businesses, often small farms or horticultural nurseries.

In Los Angeles the distributing stations initially were temples and monuments within otherwise unremarkable commercial and residential areas.[2] Later some were placed partially below ground or made to fit inconspicuously into neighborhoods. But for the most part they towered over adjacent structures, in their size and their significant form.

I started to notice the Los Angeles Department of Water and Power's electricity-distributing stations after having encountered more than a few as I was documenting storefront churches throughout Los Angeles. Apparently, from what I could gather, they were not much noted or noticed other than as ordinary unremarkable parts of the landscape. Eventually, I resolved to see them all, a picaresque that enabled me to travel to every corner of the City of Los Angeles. There are about 150 stations and sites, including generating and receiving stations. Their dispersed locations provide an effective way of seeing more of Los Angeles more systematically.

To seek, to view, and to photograph is to defamiliarize[3] what is ordinarily taken as "just there." It is "just there" in part because it is one sample of a ubiquitous phenomenon and in part because it has been there "forever." To see many electricity-distributing stations or churches, to have a catalog, to be able to compare and contrast (as they say in art history classes) is to take what is ordinary and to pay attention to its particularity, to note how it marks the streetscape, how it is woven into the urban fabric. Often you can see transformers on the roof, or in the

backyard of a station, or behind the gates of outdoor stations. Yet for the most part, this infrastructure is visible as architecture rather than as technology.[4] The look of the big-sized technology itself has not changed much over the years, although as more solid-state devices replace transformers there may well be some change.

Electrification

Electric power is comparatively easily distributed over wide areas— largely because there are conductors, ductile metals that have low electrical resistance—so that the source of power can be well separated from its use.[5] In addition power can be readily rerouted within the distribution network. There are comparatively rapid and safe electrical switches able to redirect the flow of electricity. This energy transportation system of cables, transmission stations and transformers, and receiving and distributing stations is efficient (well above 90 percent). At first electricity was introduced as a means of lighting a city, but with the development of alternating current and three-phase power, and efficient electric motors and transmission systems, electricity became the pervasive source of industrial, commercial, and residential power. What was crucial was the development of high-voltage high-power networks. In particular, the 1907 development of the suspension insulator and the development of better circuit breakers allowed for such an efficient system. Also methods were developed to regulate the voltage, so that it would be roughly constant, independent of the load on the network. This network of electric-power distribution proved to be remarkably reliable, semiautomatic rerouting allowing for breakdowns and for sudden boosts in demand.

The crucial technical facts are that larger generating stations are more efficient than are smaller ones and that you want to transmit power at higher voltages since that is less wasteful, and yet the production of power and the use of power are at much lower voltages, and the use is often at much smaller scales. Hence one needs a node that boosts the voltage of the produced power to an efficient high transmission voltage. And then, somewhere closer to users, another node must reduce that high voltage to a lower voltage. Such are transmission and receiving stations. Distributing stations then reduce that lower voltage from the receiving stations to a more widely useful even lower voltage. Large and medium users draw their power up the line.

Ideally, you want fewer generating stations, each located near its source of energy, correspondingly lengthy higher-voltage transmission systems,

and ubiquitous receiving and distributing stations located closer to the users of power, so that for most of the transmission distance the power travels at the higher voltages. Deciding on the ideal voltages, and the locations of stations and transmission lines, is an archetypal problem in operations research or optimizing, with the unknown future demand being the big uncertainty. Since these systems endure for decades if not a century or more, decisions have to allow not only for peak demands that may be encountered but also for that future growth in demand, often with little certainty about the technologies that will use the power that is transmitted. Yet if we build too large or too intensively, we waste capital.

In general there will be receiving stations located throughout the region, each feeding a group of distributing stations, which are in effect neighborhood sources of power. Initially most distributing stations were indoor stations, but with improvements in equipment, outdoor stations, often hidden behind decorative walls, became the norm. Los Angeles's system was set up before federal regulations (due to the Rural Electrification Administration). The local distribution voltage is 4.8 kV (4800 volts) in a "delta" system, considered a high-voltage system in the 1930s. There is also a separate 35 kV subtransmission system for industrial users, which is sometimes routed through the distributing stations. (The federally mandated 14.4 kV is common in most other cities.)

The Los Angeles Aqueduct (1913), bringing water to Los Angeles from the Owens Valley, has become the mythical *Chinatown* (1974) story. Hydroelectric power would be generated along the Aqueduct's way, and so the City of Los Angeles could hope to displace the private companies that had divided up the city and its users into distinct niches. Southern California Edison (SCE) eventually bought Pacific Light and Power, with SCE's distribution system within the city of Los Angeles to be bought by the City in 1919. Los Angeles Gas and Electric was absorbed by the City in 1937. Municipal ownership was a response to the failure of regulation and competition to lower rates. The resulting municipal monopoly in distribution was deliberate and involved a number of hard-fought bond campaigns for voter authorization by a two-thirds majority (1914, 1922–24).

Los Angeles's system of water and power arose during the Progressive era and reflected the principles of municipal ownership of utilities (vs. corporate ownership), the power of home rule provisions in the California State Constitution (so allowing for local taxing and bonded indebtedness), and the autonomy of agencies of government from political influence. Some of the leaders in this endeavor were William Mulholland, Ezra Scattergood (the chief electrical engineer for the system), and Dr. John Randolph Haynes (a Progressive reformer)—the latter two

being leaders in the various bond campaigns—and their names are now on electrical facilities and streets.

Encountering Distributing Stations

Even if you have a map indicating the location of each of the distributing stations, when they are first encountered they are surprising. You are driving along some thoroughfare and suddenly there is this institutional structure, perhaps in some style you recognize from stations you have seen before, almost always standing out from adjacent structures and the streetscape. It almost surely has a distinctive orange-tan color. Or maybe you turn down some side street looking for such a distinctive structure, knowing it could not be these homes, and then you run into it, usually imposing and eerily out of place. Of course, some of the time it looks just like one of those homes or those ordinary structures. But even then there is a DWP sign, and the diamond-shaped hazardous-materials marker, and perhaps a visible part of a transformer or a converging or diverging freeway of transmission lines.

Since distributing stations must be located everywhere in a city, they are likely to be intermixed with residential, commercial, and industrial users. A greenfield will eventually become filled by these users, for if the utility has planned correctly, sufficient development will occur in a station's neighborhood to justify that capital investment—if that development has not occurred already and now infill stations are needed. Distributing stations and their networks are highly durable infrastructures, and over the years they are more likely to be refitted with new transformers or other electrical equipment than abandoned for new sites.

Figure 18 maps the locations and rough dates of DWP receiving, distributing, and generating stations. Facilities radiated outward as time went on, because of development and annexation, with infill as needed. The earliest stations reflect Los Angeles's development early in the twentieth century. The core of the city developed before 1940, and then the San Fernando Valley and other peripheral areas were developed. Then there was infill during the 1980s, mostly in the periphery. Receiving stations may be located at the edges of the City of Los Angeles, reflecting a belief that Los Angeles would expand and annex further cities.

Architectural Styles

We might discern a sequence of styles of the distributing stations: in the 1920s a station was a stone temple, while in the 1930s it was

a more secular public building, and by 1940 brick began to appear. Some of the earliest stations were built soon after the 1924 vote for bonds to develop the distribution system and were monuments to municipal or public power. In the 1920s the Los Angeles Gas and Electric Company designed its temples in brick, and they look like school buildings. However, by the 1930s the newer facilities too looked like temples.

In the 1950s there were either utilitarian plain boxes or modernist temples. They yielded in the 1960s and 1970s to abstract repeated decorated bays, which may have been merely the walls of outdoor stations, where the dominant features were the very large metal doors. By the 1980s there began to appear curvaceous moderne buildings, brutalist monuments, and imitations of suburban homes. Of late there are signs that postmodern designs are possible. So we go from a transcendent vision in the temple, to the functionalist modernist vision in the factory or tilt-up building, to the piece of architecture. (By the way, for outdoor stations there may well be just a control house, not visible from the street. What is seen are the walls of the station, but the design of these walls is sometimes distinctive.)

The architecture and design of these buildings reflect both their function and technical requirements and the styles of the time or of a slightly earlier time. As for the city streets on which they are placed, often the stations still stand out from the rather lower-height strips of stores and small businesses and factories, confirming my drive-by experience. Sometimes they are monuments on islands, so to speak, with nothing adjacent to them except for the roadway. And sometimes, only rarely, they blend in with the residential or industrial character of their neighbors. What is quite wonderful is how you might see such a building while driving on a freeway: Distributing Station (DS) 28 (Sawtelle) is adjacent to the 405 Freeway, north of the 10 Freeway and south of Santa Monica Boulevard; DS 135 (Church) is just west of the 405 at Sunset Boulevard; DS 5 (Mateo) is adjacent to the 10 just east of Alameda Street; and DS 11 (Castro) is just west of the 110 Freeway downtown at West 2nd Street (and south of the 101 Freeway).

Once one begins to notice distributing stations (or storefront churches) or distribution and transmission lines on power poles and towers, one begins to see them everywhere. They are ubiquitous, but that noticed ubiquity transforms our experience of a city. The infrastructure becomes part of actual life, what we see and encounter and appreciate. Moreover, in Los Angeles that electrical infrastructure represents the peculiar history of a municipal power system, a legacy of

the Progressive era. Material culture and political history become our consciously noticed landscape.

Links: The Interstices of Los Angeles Innervated by Water, Power, Agriculture, and Transport

Globalization and communication have not yet dematerialized industry and its processes. We are still able to see and photograph the city as an archive and an artifact of bureaucracy (high-rise buildings) and manufacture (often low-rise large buildings), material networks of goods movement, labor, and marketing. In effect we have localization. What makes localization possible are the systems and networks that enweb the city: transport, electricity, communication, water, and natural gas. What makes that network almost quaint is the not-very-bucolic agriculture that thrives in the corridors defined by this system.

So when you fly over Los Angeles in a helicopter, you actually see the nerve-ways and arteries of rail lines and freeways, power-line corridors, and waterways. Such infrastructure seems to shape the environment of Los Angeles. It would appear that the Los Angeles Basin is insinuated by multi-lane paths or corridors, where on each path several of the infrastructures are co-located: power lines, roads, and waterways accompany each other, and under the power lines or adjacent to them are farms or nurseries or parks. As arterials, there are flows of materials; as nerve-ways, there are flows of information. Moreover, the Basin is quite variegated, a patchwork or harlequin of industry cheek by jowl to residential to infrastructure to agriculture to cemeteries to junkyards to military bases—much like a Petri dish of different bacterial colonies growing to bump into and invade each other. Yet these colonies need each other and are nearby each other for mutual nourishment. There are leftovers and mismatches: isolated extractive industries, such as gravel pits and abandoned refineries; or dairies now surrounded by very different uses, separated from their surrounds by streets or walls or perhaps nothing much at all. Open space is in effect mostly inadvertent, surely sometimes planned as parks or watersheds but as often yet-to-be-developed land, and sometimes a by-product of school playgrounds and fields, agriculture, or cemeteries. Most of Los Angeles is not vast sprawl; rather it is a coordinated system of systems, industry and housing hanging from a tree of infrastructure.

Often these nerve-ways and arteries were developed well ahead of housing, industry, and sometimes even larger-scale agriculture. Now these links are surrounded by homes, factories and warehouses, and schools.

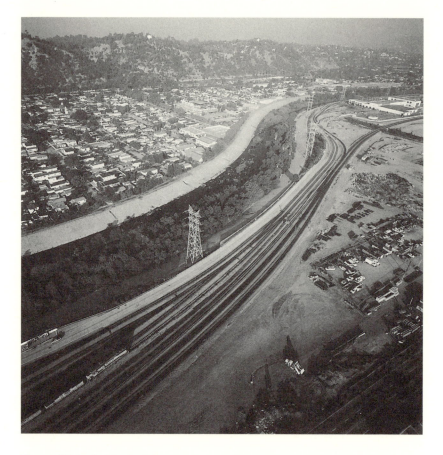

Figure 19. Taylor Yard of the Southern Pacific Railroad (Figure 1A and B, #14), the 5 Freeway in the background, with electricity lines and waterways.

It would appear that the interstices are innervated by infrastructure, although the historical sequence is most likely the reverse. Infrastructure came to appear interstitial as it was engulfed by development.

By the way, if we are flying over the Basin in a commercial airliner, details are too small to be carefully studied, and if we are driving an automobile, we cannot see the system and pattern of innervation. If the infrastructure is in our backyards, we may be concerned with noise, or flooding, or electromagnetic fields. But, again, we do not see the system as such.

The crucial rights-of-way might be shared: above-ground high-voltage electricity transmission lines; buried and above-ground natural gas

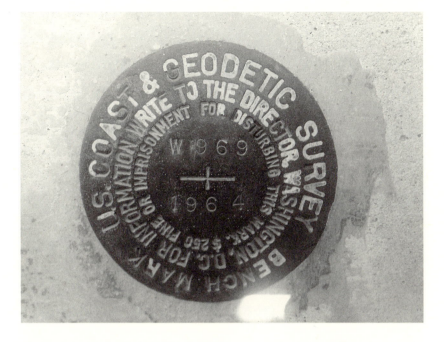

Figure 20A. U.S. Coast and Geodetic Survey (now National Geodetic Survey) benchmark at the base of a building at 6535 Wilshire Boulevard in Los Angeles (Figure 1A and B, #8). Its designation is W969, the date is 1964, and its Permanent Identifier (PID) is EW1497. It is formally described by the following: "AT LOS ANGELES, AT THE NORTHEAST CORNER OF THE INTERSECTION OF WILSHIRE BOULEVARD AND SWEETZER AVENUE, SET VERTICALLY IN THE WEST CONCRETE FOUNDATION OF A BRICK BUILDING AT 6535 WILSHIRE BOULEVARD, 25.7 FEET NORTH OF THE NORTH CURB OF THE BOULEVARD, 12.4 FEET EAST OF THE EAST CURB OF THE AVENUE, AND ABOUT 1.2 FEET HIGHER THAN THE SIDEWALK" (taken from the datasheet for EW1497).

pipelines; agriculture at ground level; adjacent waterways and rail lines and freeways. They need not interfere with each other. These co-incidences are often planned or taken advantage of by infrastructural latecomers such as telephone or cable-television or optical fiber. Moreover, the surrounding residential and industrial areas were meant to grow up around such infrastructure, and they might be seen from above as that fruit hanging from that infrastructural tree. Again, road and rail and telegraph were surely precursors.

When all is built up in an area, these rights-of-way are seen to innervate all of space. But, again, this is not a passive fact. For the most part the rights-of-way were there initially as part of long-term development

Figure 20B. U.S. Coast and Geodetic Survey (now National Geodetic Survey) benchmark W969, 6535 Wilshire Boulevard, Los Angeles.

plans, later to be ramified and articulated. Of course, the basic geomorphology of an area may have influenced the paths of rivers, the lands that prove arable, and even the location of important urban centers. So we might say that after the geomorphology does its work, there comes the infrastructure, and then the subsequently built environment modifies that geomorphology and the meaning of the infrastructure.

The City Inscribed

If you walk in a city and look down, you will note inscriptions that refer to utilities and location. These inscriptions insist that the city is systemic.[6]

Manhole covers point to hidden infrastructure, often indicating the perhaps-local foundry that manufactured those covers; stamped impressions in concrete pavement indicate the paver and the date; and metal plaques indicate boundaries of responsibility or privacy of various buildings and sites. There are as well United States National Geodetic Survey (part of the U.S. National Oceanic and Atmospheric

Figure 21. Surveyor's mark, nail with washer, placed in concrete sidewalk.
Often these marks are surrounded by white-painted circles.

Administration [NOAA]) markers or benchmarks, the most obvious
ones indicating the names and dates of the markers and perhaps other
relevant information.

Moreover, private surveyors place many such markers, usually nails
pounded into the concrete sidewalk or asphalt pavement, with *M-A-G*
on top of many nails indicating *Magnails*, magnetized and so more eas-
ily found with detectors. The markers may have alphanumeric labels
inscribed on washers, in effect pointing to exact locational information
in some database. These markers are proprietary to each survey com-
pany, although, I am told, a company may sometimes share a marker's
information with other such companies.

Not all infrastructure is visible, even in Los Angeles. However, infra-
structure and its pathways are reinscribed on the streets, making visible
what is perhaps hidden just below your feet. The visible and the invisible
cities are connected to each other.

In response to many disasters and disruptions due to excavations that
rupture utility lines, there has developed a warning and guidance sys-
tem, coordinated by the Common Ground Alliance. When one wants to

Figure 22A. Markings made in white paint by the excavators, before starting ·
work, on the concrete or asphalt, indicating the extent of a proposed
excavation (the arrows).

excavate, one places a call to 811 (*DIGALERT* in Southern California, for
example: "Call Before You Dig") and marks the areas of excavation in
white spray paint, indicating their extent, and also writes "USA" (which
stands for Underground Services Alert) and one's name. Subsequently
a utility company marks the site using spray paint ("locate-and-mark"),
with indications of its facilities in the appropriate color code. Conven-
tionally these codes indicate the company/facility/underground con-
struction description/infrastructure material, using such abbreviations
as *E* for electrical, *TS* for traffic signal, *G* for gas; *C* for conduit or *JT* for
joint trench; and *CI* for cast iron or *CMP* for corrugated metal pipe. On
construction sites these facilities are often marked with "whiskers" of
the appropriate color, a whisker being a brushlike collection of plastic
strands.

 The color code for utilities is as follows: red—electric power lines, ca-
bles, conduit; orange—communication, cable TV, alarm or signal lines,
cables or conduit; green—sewer systems and drain lines; pink—gen-
eral or temporary survey markings; yellow—gas/oil/steam, petroleum

Figure 22B. Markings indicating the company doing the excavation. Also markings made subsequently by the utility indicating, in this case, that there are no Department of Water and Power lines here. The marking is in red, with a blue W.

or gaseous materials; blue—potable water; purple—reclaimed water; white—proposed excavation.

These inscriptions will not be noticed if one is driving by or walking head-up having a conversation with a friend or colleague. You have to look down, and once you start noticing these phenomena, they seem to be everywhere, all the time. They are indicative of the built infrastructure, at our feet or just below our feet, capillaries of an artery system. In addition, of course, one might look up, sideways, and forward to note the innervating utility corridors, the adjacent agriculture and horticulture, storage businesses (including unsold new automobiles), and parks and recreational facilities. What is often seen fleetingly as you travel on a freeway is quite rich when you walk up to it and under it.

As for industry and infrastructure, a city is a delineated and inscribed and marked place: system and network, node and link, nerve and artery, indicated by an elaborate code that is the built environment, that built environment itself inscribed to mark what is otherwise hidden and

distantly linked. The system is both economic and material, flows of goods and workers among industrial nodes and residential neighborhoods, and flows of electrons and energy and water among sources and sinks: the economic and material, the industrial and the residential and infrastructural, mirroring each other.

As we shall see in the next chapter, there are as well social systems housed in the built environment, that built environment itself inscribed to mark what is otherwise hidden and linked and, here, transcendent. The artifacts of economy and infrastructure are what provide that housing and the people for that social system. Hyperbolically, there is an identity of the various identities in the manifolds of profiles. That identity is the city.

Storefront Houses of Worship

Eugène Atget's achievement in the first decades of the twentieth century, whatever we might claim for the formal and aesthetic quality of his photographs, was to find topics or phenomena that allowed for a richness in documentation: Parisian Interiors, Vehicles in Paris, Trades and Professions (*Petits Métiers*), Landscapes, Picturesque Paris, Art of Old Paris, Paris's Environs, and Topography of Old Paris. These topics had to be photographable, in effect material and objective, and located in particular places: they had to be within the range of the Paris he had access to. Moreover, they were part of a system of economy, urban planning, and state power. So, in much the same vein, are industrial sites, electricity distributing stations, and infrastructure embodied in distribution lines for electricity, water, and transport.

So too the storefront houses of worship in Los Angeles allow for rich documentation, visually and aurally. They are aspects of economy and planning, and also they are to be understood theologically and as historical artifacts. They reflect the dynamics of the real estate market, changing migration and settlement patterns, and historical streetcar routes, not to speak of denominational sectarianism. When we examine hundreds of these churches, in light of Scripture and the source of Pentecostalism actually being in Los Angeles (the Azusa Street Revival of the first decade of the twentieth century), there is much to be seen from the street. The city itself is an archive.

Storefront Houses of Worship in Los Angeles

The look of everyday religiosity in a city is discovered when we drive down the street, stop and photograph the facade of one more house of

worship and perhaps its adjacent buildings, and then move on to find the next one. So we develop an archive of images of the consequences of people's beliefs and rituals, the economy of urban real estate, and the camera, lens, and film we employ—what might be called the vernacular sacred, visual culture, and applied technology.[1]

I have photographed the facades of hundreds of small (usually storefront) houses of worship in the City of Los Angeles, along the main thoroughfares of the city, and in adjacent parts of Southern California. Most of these institutions are evangelical Protestant churches, often African American and Hispanic. ("Evangelical" is used here generically, rather than referring to a particular denomination. Also, I will often use "church" generically, rather than the more precise "storefront house of worship." There are storefront mosques and synagogues too, as well as Korean churches and Buddhist temples.)

Los Angeles proves to be rich in these institutions, in part reflecting diverse migration and immigration patterns and groups. Much of Pentecostalism—the portmanteau "denomination" of many of these churches (whether they be Anglo, Hispanic, African American, or other)—points to the central symbolic significance of the Azusa Street Mission (1906–8) in downtown Los Angeles in the development of this movement. (More precisely, the Apostolic Faith Gospel Mission, at 312 N. Azusa Street [Figure 1A and B, #12], a site owned originally by the fabled African American woman Biddy Mason, which was formerly a First African Methodist Episcopal church.)

Authentic spirituality and religiosity are comfortably present in the most mundane and commercial of realms, with no sense of contradiction or irony. The stores are usually in older retail strip developments, in less prosperous sections of the city. But some are converted commercial and industrial buildings, others are actual purpose-built church buildings but now occupied by new congregations, and others are shared or guest congregations. This is durable infrastructure—commercial, residential, and sacred; now reused, now repurposed. Often the houses of worship are spatially clustered, yet within a cluster they offer distinct niches and sectarian forms, reflecting the ready availability of these particular spaces (the rents are low in this neighborhood; the large churches are comparatively empty) and the subtle differences of theology and worship and leadership within any movement that is not highly regimented. Whenever and wherever you go looking, there are always more such places, and they are more varied and inventive than your imagination would allow. Storefront houses of worship are ubiquitous and distinctive from each other, and they are part of the weave of the ordinary urban fabric.

The storefront houses of worship, as is the case for cathedrals, wear their denominations, sects, and theologies on their sleeves: by their names, their

signs and symbols, their displayed quotations and references to Scripture. These are codes, often in languages other than English, understood by the congregants in specific concrete ways. So the city is inscribed by the people who live in each neighborhood. A facade, like a painting that has writing incorporated into it, is likely meant to be read, the viewer's curiosity piqued by what is almost legible. If you believe in a revealed scripture, so that every detail matters as it has been revealed, then every detail of these facades will also come to so matter. To be able to see it all in the photograph is to participate in revelation. In these photographs (Figure 24) I wanted to make the world so recognizable for its inhabitants.

The readily reproduced and alterable photograph may be a challenge to the conventional notions of authenticity. But the photograph here is also a testimonial to revelation and sacredness, in a vernacular that is a sign of religion's capacity to adapt to new circumstances. Such testimonials are set occasions for the theatrical display of the sacred truth. There are parallels to scientific and other such demonstrations: think here of a stroboscopic photograph of a ball bouncing, the photograph employed in a physics textbook to demonstrate gravity and elasticity.

Where They Are

If you drive down many of the main streets of Los Angeles and look to the side once in a while, you will notice many storefront churches, often in distressed retail strips. As remarkable as is the ubiquity of these churches is their differentiation, marked as they are by ethnicity, language, religious denomination or sect, and theological stance, proclaimed in lettering and iconography often large enough to read while driving by. For the most part storefront churches are adjacent to or part of working-class or poorer neighborhoods, nearby their likely members. Many of the ministers of these churches are not formally educated for the ministry; rather they are called to their vocations. Often they are dual-career clergy with regular day jobs—much like the Apostle Paul, working with their hands and wits during weekdays and serving the Lord in the evenings and on weekends.[2]

This is a vernacular architecture representing transcendent ambitions, to be realized in part here on Earth, recalling the cathedrals of the past. Building, decoration, signage, and context are strikingly informative. Rather than being idiosyncratic or rare parts of city life, these storefront churches define an urban fabric, as it is experienced visually and socially. The sacred and the religious are literally embedded in the secular and the commercial.

What is everywhere and ordinary is in each case local and particular,

reflecting the neighborhood and the church's members. Often churches are close by each other, in part due to the fact that offshoot congregations still draw from the same neighborhood, and available storefronts are likely to be nearby as well. (In the case of Orthodox Jewish synagogues, sectarian splits will lead to new congregations that are likely to be quite nearby, since members retain their same residences and must walk to services on the Sabbath.) Since storefronts are often clustered, it is perhaps not surprising that several churches might be located in one of these clusters. These institutions fill quite particular ethnic and sectarian and even social niches, specialized by nationality or race, doctrine, and extended family.[3]

Even after you have noted the sources of variation, what remains striking as you drive around is how many and varied and pervasive are these storefront institutions. Apparently they are crucial and central to much of city life, not at all marginal curiosities. Here we have a system of institutions without a center or regulation, societal infrastructure without deliberate planning or governance. Storefront churches take advantage of a local real estate market that is in decline or at least is not vigorous, so that rents are comparatively low and places are readily available—so start-up costs are modest or purchase prices are affordable. They arise out of that highly segmented market for religious life, where again theology, ethnicity, and language provide for many niches. Sectarianism and segmentation lead to entrepreneurship.

In city planning terms, we have the adaptive reuse of abandoned places, inhabiting otherwise unrentable spaces, providing stepping-stones to improved quarters for a congregation. Such urban change and transformation are consequences of the cumulative effect of many small independent decisions (for example, to establish a church, to belong to one church rather than another). Compared to established churches, with mainline denominational affiliations and special-purpose buildings, these storefront churches might be said to be part of what is called the "informal sector," more conventionally taken to be the part of the economy that is not registered by government statistics or taxes.

What Los Angeles provides is a dynamic environment, with many immigrant groups, new and established, and many areas that are comparatively down-at-the-heels. (Other cities surely provide much the same.) It is just in such places where there is both a demand for a particular form of worship and the possibility of making a place in which that can be established.

Learning to Find Storefront Houses of Worship

I used to drive to work on the city streets of Los Angeles. I know I must have seen the many storefront churches on my drive, but for a long time

I never noticed them. I now realize that there were many churches I did not see, or buildings I did not recognize as being houses of worship. For whatever reason, I began to take account of this urban fabric in a more systematic way, and then in the matter of course I just *knew* there were lots of storefront houses of worship in the city. But until I actually went out and looked for them, I did not realize how many there were, how they were clustered in certain areas or along certain streets, and how varied were their manifestations.

The Yellow Pages (and the computerized telephone directory) list many of these churches under the various denominations and subdenominations (about 120; see note 4). The Standard Industrial Classification (SIC) code for houses of worship is 8661 0000; the SIC codes for Armenian churches and Muslim mosques are 8661 0602 and 8661 1003, respectively. Since many of these churches are in commercial and industrial buildings, it is likely that they are on main streets, so one might search by SIC code or by main street. I also searched a computerized telephone directory by zip code for terms such as "iglesia" and "church" and "temple" and "mosque." Some zip codes have very many of what might be storefront churches, given my experience about terms that would indicate such churches. Others have few or none. More opportunistically, in my travels around Los Angeles, I encountered storefront churches on side streets, streets that I would not have focused on given the systematic searches.

Once you note the streets, you will see that some have a goodly number of churches. Driving around town to do your business, after a while you not only *know* where many churches might be, but you also can recognize areas that are worthy of a second look and can recognize prospective storefronts a block away. Of course, you may miss those storefront churches that are not on the main streets, or that are in apartments or homes or the second stories of buildings and do not have prominent signage, or that are in the back of a corner mall. (Zip code and SIC searches lead to some of these churches. They turn out to be much like the ones on the main thoroughfares.)

I am not quite sure just what tips me off that churches are nearby. If the neighborhood is prosperous, they are not likely. But once you see empty storefronts at a prominent corner, or even a row of stores occupied by more marginal businesses, or industrial buildings that seem unemployed, you begin to think there might be something here. If you find two storefront churches nearby each other, you know there will be others nearby or other clusters not too far off. If you drive in the right-most lane, you will have a hard time seeing the storefronts on the right. But if you drive one lane over, you might notice a storefront church on the right but then have trouble pulling over to park. And, of course, you will miss some churches unless you drive by several times.

In sum, you will not find storefront churches in stores and industrial buildings that can be rented to businesses that can afford to pay higher rents. Your best bet is to find a neighborhood with lots of commercial real estate that is underutilized or almost abandoned. It is in the nature of the housing markets that the people who live in these neighborhoods often are the people who want what storefront churches offer. Those people are quite discriminating in the kind of worship they are seeking, and so there is likely to be a variety of such churches in the area—and the ready availability of small-scale real estate makes that variety possible. So there is a high degree of both concentration and differentiation.

The maps in Figure 23 indicate places I have photographed. In general I focused on main thoroughfares, and on those that had a substantial number of storefront houses of worship. (I have not focused on New Age institutions, fortune-tellers, spiritualists, or the like.) Many of the churches are in South Los Angeles, along north-south streets; others are along the east-west Pico, Venice, and Washington boulevards. Some are in the San Fernando Valley; others are in Huntington Park, South Gate, and Long Beach.

A minister sweeping the street outside his rather more substantial church told me that on his north-south thoroughfare San Pedro Street, between Martin Luther King, Jr., Boulevard and Imperial Highway, there are more than 110 churches (averaging almost 2 per city block). So some streets are in effect lined with churches. A survey shows that those churches are often clustered, several adjacent to each other, often at the corners of an intersection.

There are many more storefront houses of worship in Los Angeles beyond the hundreds I photographed. I kept discovering churches, no matter how hard I did not look. Having learned to find these churches, I still needed to figure out what I was seeing.

What to Look for in the Images

Storefront houses of worship almost always face the street, and so their facades are as well billboards and signs, advertising their missions and creeds. Often these signs are large enough to be read while driving by. Even if an institution has since left the premises and the sign's paint is peeling, still one might read off the history of this place. When you stop and look at a storefront or study its photograph, there is a good deal to be learned:

1. The name of the institution may incorporate terms that indicate the institution's denominational and creedal commitments.[4] (See note 4 for a list of religious denominations and a list of such terms.)
2. Often the hours of worship and the particular sort of services

(women's, children's, Bible study), the minister's name, and the telephone number are given. The sign may be temporary, or distressed, or new and shiny. The finish on the building may be shabby and wearing off, or it may be pristine and permanent. Spray paint may have been used to cover graffiti. The latest paint job may have been meticulous or sloppy (look at the trim and around the gates). The houses of worship share in the well-being of their neighbors. But sometimes, as in all such circumstances, the poorest may be well maintained and neat (a poverty that has become asceticism, transcendence signified).

3. There may be a quotation from Scripture, or at least a reference to a particular chapter and verse.[5] (See note 5 for a survey of such passages.)

4. There may be a symbol indicative of a particular denomination or perhaps of a more general commitment.[6] (See note 6 for a list.) In the case of Christian churches, where are the crucifixes? Are they on the roofs, built into the gratings, painted onto the walls, or perhaps made of wood that is affixed to those outside walls, or are they neon or fluorescent signs?

5. There may be particular features of the architecture and design, say, a pointed roofline, that suggest a sacred place. There are also features that are altogether more practical, such as gates and gratings and roll-down doors, once and even now meant to prevent forced entry.

The building itself may be a corner store, or a freestanding blockhouse, or a store in a line of stores sharing a single building, perhaps with residential stories on upper levels. There may be an air conditioner in the transom. Parking may be abutting the building, or in a separate parking lot, or on the street.

Notably, in my photographs there are virtually no people and no actual religious ritual and prayer: a consequence of when I photographed (weekday mornings) and the superficial subject matter.[7] (Actually, at other times I have photographed and videoed worship in action.) In fact, most of the day the members of the congregation are not present, and the storefront is seen as such. Most services at many churches are in the evenings or weekend afternoons.

Denomination and Theology and Prooftext

Moses, Jesus, and Mohammed might well have spoken to their followers in a tent, the latter two perhaps in the marketplace or a stall in the

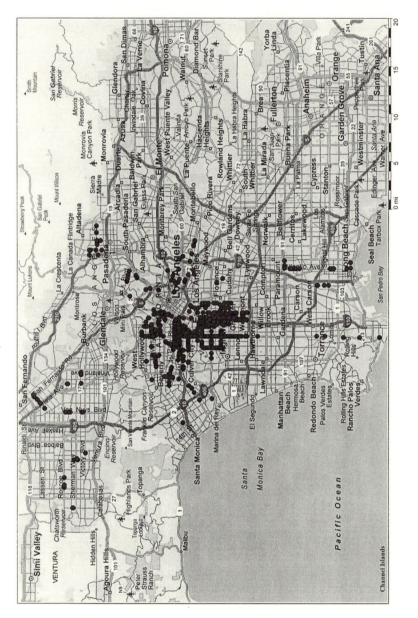

Figure 23A. Location of photographed storefront houses of worship. Map used by permission of Microsoft.

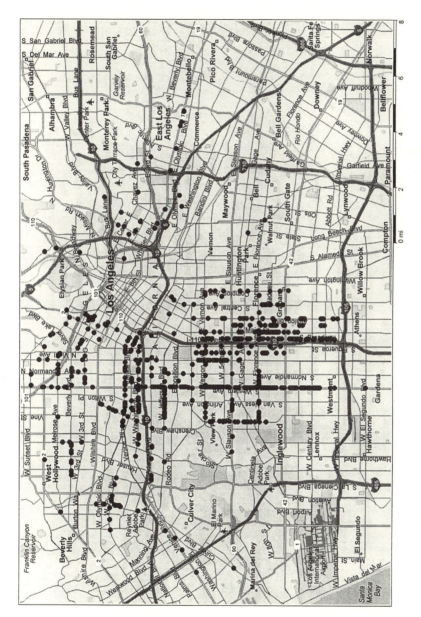

Figure 23B. Location of photographed storefront houses of worship (detail). Map used by permission of Microsoft.

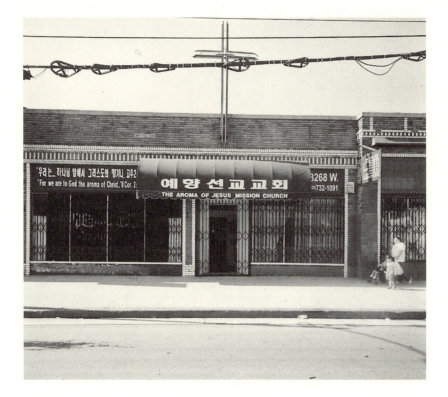

Figure 24A. Storefront house of worship in Los Angeles.

bazaar. Theirs were evangelical missions, their vocations inspired and awe-filled. But those vocations were to be fulfilled in the most ordinary of places. So perhaps it is not at all surprising that within the enormous flux of Los Angeles, there will be many storefront houses of worship, led by men and women who have an inspired vocation, often outside the mainstream practices and ecclesiastical institutions.

Christian institutions dominate the storefront houses of worship I have photographed: they are storefront *churches*. The dominant denominations and movements are Pentecostal and Baptist, experiential and biblical, respectively. As for Pentecostalism, the prooftexts are as follows:

> When the day of Pentecost had come, they [the Apostles] were all together in one place. And suddenly from heaven there came a sound like the rush of a violent wind, and it filled the entire house where they were sitting. Divided tongues, as of fire, appeared among them, and a tongue rested

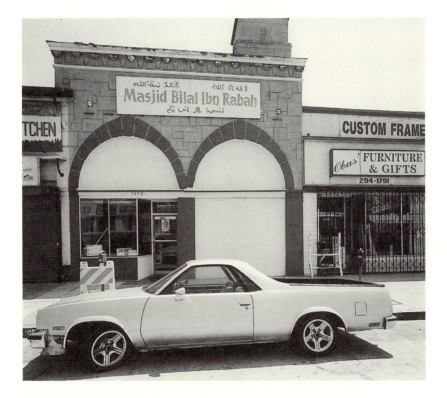

Figure 24B. Storefront house of worship in Los Angeles.

on each of them. All of them were filled with the Holy Spirit and began to speak in other languages, as the Spirit gave them ability. (Acts 2:1–4)

Therefore I want you to understand that no one speaking by the Spirit of God ever says, Let Jesus be cursed! and no one can say "Jesus is Lord" except by the Holy Spirit. . . . For those who speak in a tongue do not speak to other people but to God; for nobody understands them, since they are speaking mysteries in the Spirit. . . . Now I would like all of you to speak in tongues, but even more to prophesy. One who prophesies is greater than one who speaks in tongues, unless someone interprets, so that the church may be built up.[8] (1 Cor. 12:3, 14:5)

Pentecostalism grew out of the Wesleyan Methodist tradition of perfectionism (or holiness or sanctification; the term "entire sanctification" is due to John Wesley [1703–91]) and means, in effect, being one with God. If there is salvation (or regeneration, or baptism) as a first step, then holiness or perfection here on Earth is a second step. The third

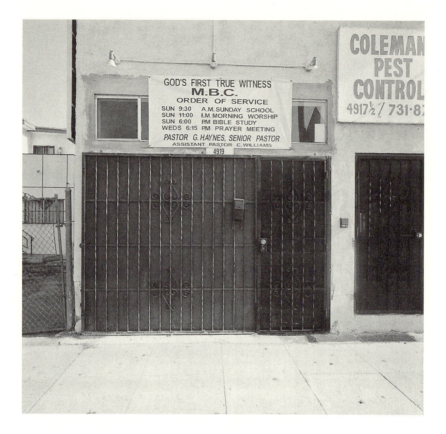

Figure 24C. Storefront house of worship in Los Angeles.

step is a second baptism or a second blessing, a baptism by the Holy Spirit, indicated by a speaking in tongues (glossolalia) or by a healing— referring now to the above passages and the events of the Pentecost several weeks after the Crucifixion. To have reached the third step is to be an Apostle of Pentecost, and so to have an Apostolic faith. Various Pentecostal movements may have fewer steps: Holiness denominations, such as the Church of the Nazarene, might have just the first two steps. Others thought that the second baptism or spirit baptism was part of holiness or sanctification, the second step. Assembly of God and the Foursquare Church are also two-step. And there is as well a fourth (or third) step, the Lord's soon return, the "latter rain," the restauration (or restoration).

What is characteristic of Pentecostalism is that (transcendent) experience can prevail over Scripture and ministry as a source of transformation

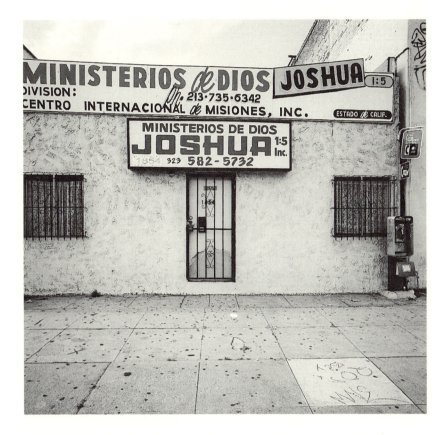

Figure 24D. Storefront house of worship in Los Angeles.

and sanctity. Salvation was available to all those who worked for it. (They were Arminian rather than Calvinist, to use technical terms.) Pentecostal churches tend to be communal and to some extent mystical in worship. In addition Pentecostals have for the most part been less privileged economically.

Pentecostalism is not the same as Fundamentalism or Evangelicalism, both of which movements have, in fact, to varying extents rejected Pentecostalism's emphasis on experience and speaking in tongues. Moreover, Pentecostalism is not so hospitable to the theological doctrine of the Fundamentalists as a doctrine, for doctrine itself may well get in the way of experience. As for Evangelicalism, Pentecostals are rather less concerned with theological orthodoxy or with influencing the culture around them.

Historically, out of the Holiness movement of the nineteenth century

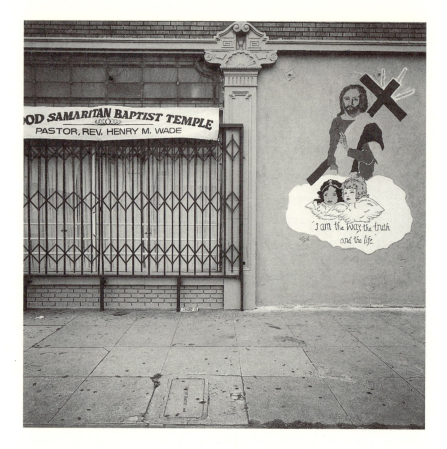

Figure 24E. Storefront house of worship in Los Angeles.

(1830s), toward the turn of the century (1880s and later), there arose groups in the United States who experienced speaking in tongues and healing and so thought of themselves as participating in an Apostolic Faith. There were many earlier nineteenth-century precedents. In Los Angeles early in April 1906 at 214 (now 216) Bonnie Brae Street (Figure 1A and B, #18), west of downtown, there was a spate of speaking in tongues. This was so compelling and noisy and drew such a crowd that the congregation moved to larger quarters downtown on Azusa Street in a former African Methodist Episcopal church. (More precisely, at first it moved to 9th Street and Santa Fe Avenue [Figure 1A and B, #19], southeast of downtown, since it got too large, then back to Bonnie Brae when it was locked out of the Santa Fe location, and then to Azusa Street.) The congregation was now in a nonresidential area, so all-night meetings

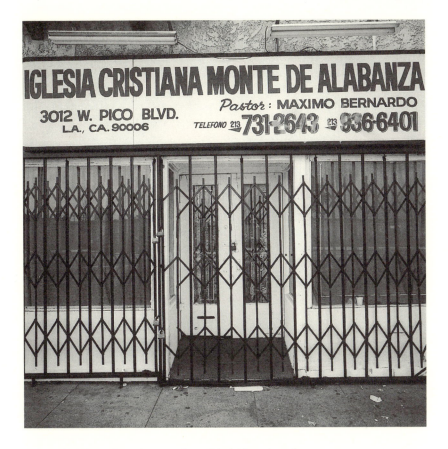

Figure 24F. Storefront house of worship in Los Angeles.

would not disturb the neighbors. So the symbolic cruxal moment has become April 1906 at the Apostolic Faith Gospel Mission at 312 Azusa Street (the building is no longer extant) in downtown Los Angeles, the so-called "Azusa Street Revival."[9] (Farther north, on April 18 San Francisco experienced a strong earthquake and a subsequent fire, an event taken as significant in these quarters.)

Out of that Azusa Street moment a variety of denominations were redefined and new ones flowed, in part reflecting racial and theological polarization. So, also, other groups and denominations, which had somewhat earlier entertained signs of the Holy Spirit and the second baptism, came to be seen in the light of the Azusa Street Revival.

However, Pentecostalist churches did not arise only out of Holiness movements (and, of course, not all congregations in storefront houses

of worship are Pentecostal). The major Korean migration to the United States from 1965 to about 1990 was largely middle class, the most Christianized class in South Korea. Methodist and Presbyterian missions had succeeded, but the level of religiosity of these immigrants, when they had lived in Korea, was not intense. In the United States the converted returned to their church, and in the context of the uncertainty and anomie that comes with immigration, they became more committed to their churches than they were in Korea. Some of these Koreans remade their churches to provide for a more intense form of worship and experience than was available to them in Korea.

African American Baptists of the Great Migration north found the style of Pentecostals in accord with their own modes of worship, as well as providing a sanctified space insulated from the alienating urban and white world.[10] They were spatially concentrated and segregated, so their needs could be readily met. Hispanic Catholics who migrated to the United States found the U.S. Catholic Church wanting in community and religiosity, and they were drawn to Pentecostalism, the differences in theology being not so significant for them.[11] Catholic charismatics found new ways to worship outside of the cathedral. In each case experience came to dominate episcopate and Scripture. Congregations were often small and subject to sectarian splits, and unaffiliated congregations were important sources of religious innovation.

Established churches might well have felt that these new institutions were stealing their natural members. What was simply evangelizing by these smaller churches, spreading the Word and meeting the specific needs of their communities in small, readily accessible sites, was seen by the establishment to be proselytizing. In effect, the mass producers were being displaced by flexible and specialized entrepreneurial firms. What for the established churches was theologically a matter of ecumenicism and organizational unity, for the Pentecostals became a spiritual or personal unity. It could then be argued by the establishment (although the facts speak otherwise) that this personal unity leads to an isolating individualism that can be readily attacked by mundane commercializing forces, so destroying the sacred realm and its power to resist moneymaking.[12]

Script and Symbol

It is a commonplace of introductory art history courses to interpret the gothic cathedral in iconographic terms: each figure coding a different meaning, the mode of representing the figure providing further details in that coding. To follow the interpretation, the twenty-first-century

student needs to know something of Christian theology, ritual, and Scripture. And it is said that this form of iconographic presentation was for an audience that was for the most part illiterate.

The contemporary city is inscribed with signs and billboards (and Marville's images indicate that this was the case in Paris, circa 1860, too). Writing and logos and images are everywhere, at least where there is commerce and traffic. Those inscriptions are coded in a variety of languages, reflecting the diversity of the population. So storefront houses of worship are inscribed on their facades: their names, their prooftexts, their hours and services, and their symbols. Those inscriptions are meant to be read by passersby, whether on foot or in an automobile or bus, as well as by members of the church.

Names

The name of an institution often includes the denomination; a particular, often scriptural tagline; and sometimes, in the case of the Pentecostal churches, some Hebrew terms drawn from the Hebrew Bible (*Shekinah, Shalom, Mahanaim*). In the case of Jewish synagogues and Islamic mosques, there is almost always Hebrew or Arabic script displayed and employed, sometimes without translation—not necessarily because this is the language of the members but because it is the language of the sacred book or Scripture. On the other hand, the languages of their members and the distinctive characters of those languages often denote Armenian, Cambodian, Russian, Greek, Chinese, Vietnamese, and Korean churches, whatever their denomination.

Now, it is not without theological consequence if a church announces that it is legally incorporated ("Inc."). Legally, incorporation allows for limited liability, the members of the church not financially responsible for the church's debts or legal judgments in the case of successful liability suits. Theologically, the church is now defined in part by the secular state, and some have argued through biblical references that this is giving up church power and autonomy for a dubious benefit. Others then argue that the problem is merely to keep the state out of creedal and religious matters, an important issue in United States constitutional law. These turn out to be lively and serious theological matters as well.

Symbol

The symbols on a facade or a sign may include animals (dove, fish), parts of the body (a handshake, an eye), objects (the cross, the cross on a globe, the six-pointed Star of David), or natural phenomena (clouds, rain). Foursquare churches have four symbols, forming a symbolic logo

representing Christ as Savior, Healer, Baptizer, and Soon to be King—cross, dove, cup, and crown—and the four precepts: conversion, physical healing, second coming, and redemption. Such symbols are usually traditional in their meaning, but their meaning for the members of a particular church is not given simply by the conventional tradition. In addition, the words and pictures would seem to have a rather more contingent relationship. Only if we know the group's theology and culture can we be sure our interpretation is about them, rather than about ourselves.[13]

Often the Bible is portrayed as an open book, its writing indicated by what might be a squiggle. If you could get closer, you wonder whether you actually could read the text, or is it just a squiggle? Also, the book may be facing the viewer, rather than a person who is depicted as reading it.[14]

Notably, the cross is ever present, but it is an empty cross, Christ not present.[15] This absence reflects a displacement of the once-hegemonic Catholic heritage by the Pentecostal antiestablishment commitment.

Text

On some of the facades a specific biblical passage is referred to by chapter and verse, and perhaps part of the passage is written out (sometimes, again, it is in the text of a displayed book). There are passages that might be prooftexts for Pentecostalism (for example, referring to healing or to speaking in tongues), but there are as well more generic Christian messages open to a variety of doctrinal interpretations. Some of the texts explain the symbols. So Jesus is taken as the true water of life, the Spirit that was given at Pentecost after he was crucified. And, again, some are prooftexts for the name of the church.

As for the relationship of name, symbol, and text, the art historian Leo Steinberg suggests that images can have a primacy, not subject to textual proof for their interpretation.[16] (His concern is paintings of Christ and their connection with Scripture and theology.) Steinberg's point is well taken, but in the cases here at hand the textual references are explicit and deliberate and often literal. How those references are to be understood might well be unorthodox, given the systems of authority and education for many of those who participate in and lead storefront houses of worship. Yet these interpretations are in effect commonplaces in this culture, not at all esoteric, and may reflect a new orthodoxy. Of course, for storefront houses of worship of denominations other than Pentecostal, or other religions, one might expect different scriptural themes, drawn from different scriptures.

The sublime and imposing facade of a cathedral becomes in these storefront houses of worship a sign atop a glass window, or painted inscriptions and symbols on an otherwise blank wall. Whether a cathedral or a storefront, these are sacred places marked by ritual—namely, everything is meaningful here, nothing without interpretation and import, all choreographed as necessary. Yet, for storefront houses of worship, much is inherited from the profane commercial and industrial history of each place, from the windows to the doors to the board on which the sign is painted. The sacred and the profane are comfortably co-present. Eventually there might be renovations and rebuilding, but at first we have what was once a commercial or industrial building, a store, or a home, or a shed, or a garage. (Sometimes the previous uses were sacred, perhaps a different church or a different denomination.) And if it is a commercial or industrial building, it is likely to be located among other such buildings, many of which still house actual businesses and manufacturing.

In time not only might there be renovations, but there might also be a rededication of the building, perhaps with a cornerstone that memorializes the history of the church and its members. The congregation may have bought the building, its price being affordable, its former owners letting go of real estate that no longer pays well for itself.

For the members of a congregation, the facade and the building are significant of worship and creed and community. These are not pieces of architecture, seen as having wonderful vernacular designs, or unseen places in which people worship, or scenes of newsworthy events (as in photojournalism and documentary).[17] They are places of ritual and history and memory.

Documenting the Sacred and the Transcendent

Most storefront houses of worship are apparently mundane and utilitarian. The store is in the everyday world, on the street. How might this place be seen as sacred (and not only labeled as such by its inscriptions and decoration)? Yes, worshippers put themselves in place so that the choreography of worship is possible, but what more is going on?

What we see and its meanings are multifold, dense with references to previous uses of that same storefront or building. Each of the many sets of references is rich enough to fully determine the meaning of what we see. Those multiple meanings may appear to be contradictory, and yet they coexist within this place and its space. We say that what we see is polysemous and overdetermined.

What is crucial is that the storefront house of worship is an actual place where people worship and practice. They sacralize the place, as it is sacred for them. To appreciate it as they do, we have to give credence to their practice, take seriously what they take seriously. For them, the place is more real than any ordinary material reality.[18] The image or photograph itself is not enough; we need to inhabit the image (here, with the potential for actual worship) if it might picture the sacred.

Transcendence is a tension between the enchanted and the disenchanted, between the universal and the particular. Photographs of the transcendent display that tension.

In the late 1950s the photographer Berenice Abbott was hired by the Physical Science Study Committee at the Massachusetts Institute of Technology (MIT) to produce photographs for a new high-school physics textbook.[19] The photographs represented various experiments and demonstrations of physical principles. (One of Abbott's most striking photographs is of a wrench being tossed across a table, its center of gravity moving in a straight line while the wrench rotated around that center.) The photographs demanded great ingenuity in their setups and their lighting, so that the viewer (a student, presumably) would see what was supposed to be seen. The photographs are as well formally eloquent artworks, reflecting Abbott's career as a documentary and fine-art photographer. What is especially striking to me, trained as I am as a physicist, is the apparent interplay of the universal laws of gravitation or electromagnetism (many of the photographs illustrate features of these laws), as I have learned them, with the aesthetic quality of the photographs. Moreover, the location of these images would seem to matter: silver-gelatin photographic prints on a gallery wall (conventional photographic prints as works of art), illustrations in a physics textbook (instrumental images), or gravure or duotone plates in an art book (reproductions).[20]

Abbott's original photographs (which I used to pass in the hallway at MIT) have aesthetic strength and scientific validity, and they are didactic as well. They display an artificial nature, the careful setups meant to display the laws of nature. They are a claim to universal truth. But just as the image of the storefront church has to be inhabited by worship, if it is to be sacred, here we have to bring to the image knowledge of the laws of nature and how they might be displayed so that we see what is being demonstrated, the laws' universality. The aesthetics are subject to that truth.

The photographer Walker Evans said, "I think what I'm doing is valid and worth doing, and I use the word transcendent. That's very pretentious, but if I'm satisfied that something transcendent shows in the photograph I've done, that's it. . . . I know by the way I feel in the action

that it goes like magic."[21] Consider the photographs of hand tools Evans made for *Fortune* magazine in 1955.[22] Again, we have composed and beautiful images of objects, objects otherwise meant to be used to do mechanical work. Here we have the tension between beauty and practical use: just what makes the tool available for a photograph so that the photograph displays transcendence is the actual design of the tool that enables it to work well and look handsome or good, and presumably that it actually does work well as a tool. As Leonardo da Vinci put it, "Your tongue will be paralyzed with thirst and your body with sleep and hunger, before you depict with words what the painter will show you in a moment."[23]

Aesthetic considerations do play a role in design, of course. Mechanical design is in part visual and aesthetic, and so the objects are made to be seen as well as used and held. Designers have always connected form with function. The Evans photographs have a neutral background with shadowless lighting, for a moment alienating these objects from their usual, messy, septic circumstances of employment. So their brushed chrome texture is now much like the deliberately chosen texture of the background paper. However, their practical use is ever present (the essay's title refers to the "common" tool). That is why Evans was interested in the tool. It is that practical use that allows for transcendence.

It has been noted that Evans's style in earlier photographs of African art (1935) is echoed in his photographs of common hand tools.[24] And we know he wanted to focus on the sensuous character of the tools: "a certain monkey wrench is a museum piece."

How do the particular features of the hand tool play a role in the photograph, taking account of the kind of practical knowledge the viewer might have about using such a tool? We have discussed how particular features of the facade of a storefront house of worship play a role in a photograph, now taking into account that it is the place of worship, perhaps for that viewer: the photograph is inhabited by worship. So someone who uses a tool for his or her work might well see it in a transcendent way: the photograph as inhabited by practical use. (The transcendence of this museum piece is a presumptive "appreciation" by those who do not worship, who need not work for a living with their hands, who do not use the tool.)

Parenthetically, I should note that photographs are employed for religious purposes, not all of which are sacred. In the nineteenth century staged photographs of biblical scenes were popular.[25] Missionaries photographed their lands and peoples to appeal to the generosity of the parishioners back home. In addition, photography has been employed to ascertain miraculous and transcendent facts, whether as testimony or as a means of discovering the hidden. The resulting photograph

can become a fetish, or an icon, worthy of intense religiosity; or it can become an iconoclasm, mocking that religiosity and its transcendent claims.

So photographs may document the sacred, demonstrate scientific truths, or display the transcendence of the practical, giving enormous power to mundane facts and objects. Cecil Beaton used one of Jackson Pollock's drip paintings as background for a fashion shoot for *Vogue* (1 March 1951). Charles Sheeler photographed the Ford River Rouge plant (1927) so that it, too, shared in his precisionist style. In each case art lends its potentially transcendent power to ordinary artifacts, at least as they are photographed. Since most such photographs are to appear in printed books and articles or on computer screens, the details and fineness of original photographic prints are subject to the mass effects of the printing press and the raster scanner.[26] The transcendent is brought back down to earth.

The photographs I have made are documents, whatever else they are. The storefront churches and the factories are actual places made and inhabited by worship and work, inhabited by people in the course of doing their work. I am interested in that work and how it is made evident.

The photographs are descriptive, applied, functional. They record ordinary, vernacular, plainspoken fact, to use the photography curator Peter Galassi's terms. Galassi, referring to Walker Evans's work, says that "the full power of the art resides not in individual pictures, no matter how fine, but in an open-ended accumulation that progressively defines both a subject and a way of looking at it . . . [so that there] develop[s] a consistent outlook through a sum of discrete observations, constantly subject to revision."[27] Tomograms and phenomenology: an identity in a manifold presentation of profiles.

Such photographing depends as well on "know[ing] enough about the subject matter to find its significance in itself and in relation to its surroundings, its time, and its function," as Roy Stryker suggested about the photodocumentation projects he directed for the Farm Security Administration and for Standard Oil of New Jersey.[28] I began in the street, then moved to the library to read about industry or infrastructure or Pentecostal religion, and ended up back in the street talking to people. Only then could I understand what I had been photographing; only then could I ask questions of the photographs and of those in the factories and churches. Only then did I appreciate an adequate identity in that manifold presentation of profiles, an identity that could accommodate and produce that panoply of documents.

I have articulated a way of looking and documenting and seeing that is historical and cultural and economic. What is seen, its meanings, and

what it does not mean are perceived in a context of a particular time and place, in the context of a corpus, that manifold.[29]

Moreover, every detail in a picture can matter, and matter in many ways. The visual is an autonomous realm, only contingently subject to the textual or the scholarly, much as actual religious practice is only contingently related to Scripture. Pictures and practice can hold what are otherwise taken to be conflicting and contradictory, the secular intermixed with the sacred. Our task is to find the actual identities, to revise our prejudices in light of evidence.

The Urban Aural Sensorium

The Sensorium

The sensorium is that manifold of sensations (actually, material objects such as photons, sound waves, stress and strain in materials, and individual molecules) that impinge upon us, so making it possible for us to see, hear, smell, taste, and feel something. In general, it is thought that cities are very rich with such sensory manifolds, although the countryside has its partisans as well. Faithfully recording that sensorium, so that it might be experienced at a later time, is one of the great challenges of art and literature, and of science and engineering.

Cameras are not eyes; nor are microphones ears, and not only for lack of stereo. Rather, our sensory apparatus is part of our neural system, a system that is extraordinary in its processing and imaginative capacity. Moreover, we are simultaneously multimodal: seeing, hearing, smelling, and so forth, all at the same time, the senses and our understandings of our experience interacting with each other. Also, the flow of impinging information may not be on a straight line: diffraction, diffusion, and reflection are all important.

We are able to take that multimodal sensorium and focus our attention in remarkable ways. At a party or in a crowded room, we can pay attention to the person we are speaking with, in effect masking out other nearby conversations even louder than our own. And we can move our bodies to enable us to hear better, see more clearly, feel more subtly.

So, it is an enormous challenge to record and re-create a sensorium. (Do we record all that impinges or focus on just what we attend to?) We can only approximate. For sound, for example, we aim for volume and

pitch to be accurate, timbre to accord with the sounds we remember most, and room effects on the acoustics to be benign. We also try for an accurate sense of envelopment and presence for spatial accuracy, so there is a sense of the surround and the nearby; for imaging, so directions and distances seem about right; and, in a multimodal presentation as in a video, for sound and whatever we see not to contradict each other.

Sound fields may be monofocal, from one source (but there are likely to be reflections from walls or trees), or multifocal as in a street scene, with foregrounds and backgrounds that may conflict with what we take as the main sounds. Usually we can find thematic unity in what we hear despite that cacophony and conflict.

We may record public aural *ambience*, where ambience refers to what might be called "background sound," usually unavoidable, pervasive, sometimes varying, and to be ignored if possible while you are up to your tasks. To record public ambience is to be up to a new task, *attending* to what is to be ignored or masked. Public ambience may include industrial noise; passing conversations; traffic and infrastructure; sounds of heat, ventilation, or air-conditioning in buildings; people playing basketball or shopping; commerce; bells and pings of automatic teller machines, universal product code scanners, or cash registers; other people in the room when in a restaurant; the sounds of worship coming from a church; construction machinery at a work site; or flatulence. Of course, in other places it may include nonhuman animal sounds, wind and rain, or plants rubbing against each other. To accurately and archivally record public ambience in Los Angeles is to create a documentary record of an urban place, to be interpreted and listened to in decades hence. We are interested in the everyday and ordinary, and their patterns and disruptions.

What is remarkable is that in public there would seem to be little expectation of privacy. Conversations are loud; cell phone conversations are broadcast. Everything is available, not always but remarkably often enough. On the bus two men in their thirties may be discussing the benefits of regular enemas and their mothers' use of them, while a young woman on a cell phone is describing the governmental and charitable benefits she is receiving since she has become disabled due to an accident and also her need to find a job soon.

It may be useful to describe my recording of a person I call the "Tamale Lady."[1] As for how it happened, we had done a number of projects in Boyle Heights and nearby areas of the east side of Los Angeles (Figure 1A and B, #3): photographing the Pico-Aliso industrial area's streets (Figure 1A and B, #2); photographing formerly Jewish sites in now-Hispanic-Christian Boyle Heights; and aural and video documentation

of street life, including people in conversation on Boyle Heights's main street, East César E. Chávez Avenue (formerly Brooklyn Avenue) at Breed Street (famous for its large synagogue nearby). I knew the surrounding area reasonably well from the Jewish sites project, so I drove around until I found a place to park (Figure 1A and B, #17), took out the recording system, and put the microphone on a tripod poised on the car's hood. I was ready to record the quiet hum of the street, the not-so-distant pervasive sounds of the freeways that surround Boyle Heights, the birds in the trees, and so forth. That a vendor would be selling tamales in the neighborhood is probably a commonplace; it *is* a Hispanic-Mexican neighborhood.

I was prepared, but the Tamale Lady was a fortunate discovery. I could hear her coming; she was calling, "Tamales!" Quickly, but not instantaneously, I decided to try to record her (even though I had already missed at least one or two of her calls), turned on the recorder, and just waited. (In my experience I have missed some valuable recordings and photographs in the time between "instantaneously" and "quickly." Being "prepared" means going into action, even if it turns out not to be fruitful.)

As for the recording itself, it was made on a residential street, with no loud industry or other such sources of noise nearby. Yes, the birds were singing, cars went by and some of them were quite loud, and car doors were slammed, but otherwise there was no persistent loud sound or noise. The vendor was approaching from a distance on her tricycle, then went past me, and then moved off: in this process she became louder, so it was easier to hear her call, and then her call faded off into the opposite distance. Depending on one's aural acuity, the number of "Tamales!" you hear when her calls are reproduced at the correct volume is between eight and thirteen. Even the quietest ones, those below the ambient noise level, can be heard since they are information and not just more noise.

Again, this is a Hispanic neighborhood, and so a tamale vendor is as natural as was the ice-cream man or the knife sharpener's truck coming by sixty years ago in my Bensonhurst, Brooklyn, New York neighborhood. This is everyday, not something extraordinary, and most people pay little attention to it—unless they want to buy tamales. Her call is part of the aural street furniture of the neighborhood.

I have also recorded at a small foundry, various manufacturing sites, a popular Beverly Hills restaurant, and various markets and stores and bazaars. I recorded the sounds of traffic on particular streets at different hours in different neighborhoods and districts, conversations in public on the bus, making a music video on the residential streets of Los Angeles, worship services at storefront churches, a train station, Hollywood Boulevard dense with tourists, and a quiet workshop where a man was cutting fabric, with an electric knife, into pieces that would be

sent to sewing machine operators at another company to be made into clothing. Note that quiet places, with the hum of fluorescent ballast or air-conditioning or people shouting in the distance, reveal the power of one's recording system and one's aural acuity.

What might you learn from such recordings now and in fifty or one hundred years? Surely you would learn what it sounded like or even gain material for an interpretive essay on the sound environment. However, what is crucial is that you can play back a recording again and again, and so discern details you would have missed on a first listening or if you were there. Just what else is going on on the street or at the site? You are trying to connect the aural environment to society's functioning, whether it be manufacturing, "doing" lunch, tourism, or the informal sector (the Tamale Lady): car hum, iPod music escaping from earbuds, machinery heard through an open window, or intrusive cell phone conversations. That is, the recording is a trace of society, and so it may provide access to what is meant to be ignored or is underappreciated. Correspondingly, Marville's systematic photographing of Paris's streets, circa its evisceration and reconstruction, and Atget's photographs decades later provide us with a level of detail that is perhaps unparalleled (the very large glass-plate negatives hold enormous detail). Those details are there to be discovered by us.[2] For example, there is a rich record of advertising and commerce provided by the window displays and by the signs painted onto the buildings.

Murray Schafer, in *The Tuning of the World* (1977), has provided a systematic account of the aural soundscape.[3] He refers to the "hi-fi" of the countryside and the "lo-fi" of the city (where the high sound levels mask much of what might be heard), and he describes how the Industrial Revolutions produced new and pervasive sounds that now envelop us—the clash of metal parts, traffic, and the sixty-cycle hum of electrical utility lines and their higher harmonics. We have to learn to hear just what we have trained ourselves to ignore while doing our everyday activities, the only partially understood and multiply conflicting threads of sound in an environment, the spectrum of quiet places, the details masked by grosser sounds, and the long, apparently boring times when nothing would seem to be happening. Ideally, we might hear all of this the first time. A recording allows us to get closer, to hear again more of what is actually going on.

Recording and Playing Back

How do we record and play back? We use microphones that have smooth frequency response and that are quite linear, so that the electrical signals

Figure 25. Recording street aural ambience on 4th Street in downtown Santa Ana, California (Figure 1A, #9).

they produce are faithful to the sounds they pick up. The microphones are chosen to have directional responses that complement each other, so that we may record surround sound. The recorder faithfully converts their electrical signals into digital records with more than enough accuracy in frequency and loudness. The microphones (see Figure 25) are in a windscreen (which looks like a large gray sausage) to slow down the sloshing of air due to wind.

The recorded signals are then processed to produce a surround-sound track, much like that which accompanies the picture in a DVD movie disc (*Dolby Digital, 5.1*). We play the sound track on a modest home theater system. The loudness is calibrated by a separate noise sound track that should have a specified decibel level, and we adjust the volume of the amplifier to achieve that level. Then the other recordings are also accurate in play-back volume.

So I go out into the field to record that urban aural sensorium as accurately as I might. While doing so, I am listening to the same aural environment as picked up by the microphones. (I am not wearing headphones.) But I am likely to be focusing on particular sounds, while the

microphones indiscriminately pick up everything. When I play back those recordings in surround sound, I am now in a room abstracted away from the original environment, and I must now listen my way into that original environment. This is no mean achievement. What is remarkable is that I am able, some of the time, to hear my way into that environment: my imaginative draftsmanship is up to the task. I made the recording; I have been here before; I may have photographs or recall the fragrance of the place; I can recall places similar to the original one. Now, however, no one is jostling me; I am in a different place. What I heard then is more selective than what the microphone recorded. So *now* is sort of like those original places but still very different. It is not the first time I have done such imaginative reconstruction or recognition; but each time, with a new site and soundscape, it is remarkable and striking. I am there, but I am not actually there.

The enveloping character of the sound, and especially of surround sound, is crucial. The sound levels are roughly correct, as is the sense of spaciousness and imaging, allowing for more subtle discriminations. Correspondingly, with photographs, roughly accurate colors matter, but what is crucial is perspective, a sense of visual envelopment and spaciousness. The photographic image has to encompass the same angular dimensions we might experience in the original scene. Typically, for an 8 × 12-inch print taken with a normal lens on a 35 mm camera, we ought to be about 16 inches from the print, but with a very wide-angle lens we need to be about 6 inches away. (Larger prints would allow for greater viewing distances but the same angular encompassment.)

A Panoply

The aural sensorium is experienced temporally and spatially. Playing back a recording, again and again, allows you to hear missed sounds or threads and pay attention to different directions and sources. Listening to a surround sound recording facing forward and then back allows you to hear more of what is going on. Other aural tomograms, such as multiple recordings of the same venue from different perspectives or at different times, would at least initially seem to exceed my own imaginative capacities for an identity in a manifold presentation of profiles. If I have a photograph or even a schematic map, I can begin to attach sounds to places—and that surely helps. By the way, this is just the realm of sound design and sound editing in motion pictures, where there is picture as well as sound. Tomography then becomes a panoply of multiple layers working together in the service of story and engagement.

My experience has been that I am more capable of finding an identity

in visual tomograms, and that supplementary aural recordings or synchronized sound in video do help me in finding an identity in my visual tomography projects. Multiple recordings or photographs or videos, from different times of the day or different eras (here think of the Paris Marville project), make me acutely aware of differences, contrasts, and continuities; but the identities are sometimes illusive. Discerning the identities is aided by historical, sociological, and economic knowledge, what I have been providing in Chapters 2 through 5.

Eventually, however, there is an identity that then allows for the aspects I encounter aurally, for my experiences of listening to a suite of recordings. For this identity, I am in effect not listening to a recording. I am now *there*, understanding how the recordings reinforce each other, make sense in that world, and lead to that identity.

Beyond mostly visual urban tomography lies a multimodal panoply. The challenge is to find identities in such a manifold presentation of profiles. The opportunity is provided by our actual fieldwork, the world itself. Admittedly, I am only at the initial stages of this project.

Chapter 7

Finding Out Where We Are

In our everyday lives we have local nearby sensory information: what we see, hear, smell, and so forth. We move around, things change around us as well, and usually we are able to incorporate that local information into our ongoing global sense of where we are, filling out that sense, a global sense that allows for all of its aspectival variations (namely, that sensory information).

We use all of our sensory capacities, so that if things make sense visually but not aurally, we wonder if we understand what is going on. If things make sense in several sensory dimensions, we feel more confident. And if we are dubious, we explore our tentative notions through checks and double checks.

Say we lived on a doughnut but at any one point knew only about the nearby small patch. Still, eventually, we might figure out that we lived on a doughnut (much as we might figure out that the Earth is a sphere). Nothing you learn at a few localities will tell you that global information, but at some point you may suspect that something is different from a hole-free world. So you try out some tests that indicate that things "go around" in two ways (through the hole and around the hole): it is not like a sphere.[1]

You do not start out with nothing. You are starting out with some rough guesses or past experiences or presuppositions (say, that you live on a sphere) that have to *accommodate* that set of patches, those aspects. You try to incorporate the various aspects, slices, photographs, videos, and audios to get a richer sense of the whole, a whole about which you already have informed notions. Now, your guess might not be sufficiently accommodating, and you are forced to revise it. Eventually that incorporation

is actually a filling in of detail—a fulfillment, so to speak. Figuring out is not a calculative process here; rather, it is a matter of imaginative drafts-manship, so that once you have figured out what it is you are seeing, you can now account for how it appears in all the various aspects.

One of the consequences of paying attention to local information is that often you do not need latitude/longitude-type information. The local contextual information tells you where you are, now in relation-ship to other nearby places, especially if the objects or sounds are in a well-defined area such as an airport or a neighborhood, an area you have surveyed already. In effect, every image or sound is already tagged (not formally but substantively) by its relative location and even era or time pe-riod through the substantive facts of scene and sounds. (This is the stock-in-trade of motion picture set designers or of persons who are blind.)

Say that you were to learn about a place through a set of photographs and sound recordings, that "learning about" in the context of an initial notion of the place. Could you imagine a more accommodating place, so that those images and recordings now fit better into the detailed global setting, that set of aspects as now being presented by or being available from that global setting?[2] That is our archetypal problem.

A place is delineated by substantive contextual facts that the place will accommodate. The wholeness of the world is discovered under the aegis of the world's presentation of itself in your interaction with it, and con-sequently of your already knowing something about the world, how you presume it must be configured. Similarly, say you are trying to under-stand the organization of an institution, whether it be a bureaucracy, a terrorist cell, or a discipline. You have lots of local information, perhaps from many places and times, concerning its connections and linkages. Some of that information is reliable; some of it is less reliable or inferen-tial. Still, it is information *about* some thing or some place.

You want to figure out better how the institution is structured, and so you need a way to reorganize your information, taking into account the quality of that information. Initially you might have thought in terms of some general structures (such as one person at the top, a network with several centers, a network of networks). You never start with nothing; again, it is information *about* something. You confirm and modify an in-ferred global structure employing local observations. Or you more radi-cally modify the tentative structure, what that information is supposed to be *about*, to accommodate more adequately the information you do have. When we visit someone's home, we do this in bits and pieces as we go around the house, keeping in mind that we have seen many other homes already.

Put differently, how do we get hold of the experienced *objective* world? We make *dense* observations, observations that are about that presumed

world, observations ubiquitous in space and time, systematic and more casual, but then indexed or tagged by locale and propinquity: *tomograms*. So we may present the world back to ourselves. Examining these dense observations, starting out *already* with that preliminary idea of what the world is like and so what it is we are seeing and hearing, we *fill in* details, correcting preconceptions. So we *figure out* what is going on in acts of *imaginative draftsmanship*. We rediscover the *tissue of negligible detail* that makes up the concrete particular world. Those details and those preconceptions are aspects of purposeful activities and actions, and so what we are discovering is a dance and a *choreography*.

Later we can *theorize the world into abstraction*.

Urban Tomography

Urban tomography, with its dense and multiple perspectives in space and time and type, allows for exploratory analysis of the world in front of us. Those hundreds of examples of storefront churches or of electricity-distributing stations encourage us to see each corpus as an institution provided within a society, rather than as a disparate multiplicity of sites and buildings.

Multiple perspectives viewed in parallel, and re-viewed, allow for seeing it all, again and again, so that you begin to figure out what it is you are seeing: flows, phenomena, types—not just individuals. For example, the intersection of several major bus routes allows for many more activities than just changing buses. The businesses at this corner (both formal and informal enterprises) depend on those flows of people, and of course there are places other than buses that people are moving toward. To be present at such an intersection is to be aware that you cannot keep track of it all. By the time you understand one corner, the hour has changed and the flows of people are also changing. Urban tomography allows you to review what you have seen, again and again, and then to see it all as a whole, an intersection of related flows, that has provided those aspects.

Dense Observations from Multiple Perspectives and Temporalities

Physicians appreciate tomograms because they can see more detail, and also because they get a more rounded and complete view of parts of the body, a whole about which they already have informed notions. So that fitting together of the slices is actually a filling in of detail—a *fulfillment*, so to speak.

In a Doppler echocardiogram, physicians see the blood flows from one perspective and know that those flows must accord with flows observed

in other perspectives. More generally, the organ one observes from an initial aspect (and one's conception of the organ) must somehow be able to provide material for other observation modalities and other points of view. That is what we mean by *an object*, I believe.

One brings a great deal of (here, physiological and anatomical) knowledge to viewing such tomograms, but initially you may not recognize peculiar situations: they are problematic but not yet labeled and given an objective presence in the world. (Is something wrong here? What is the *it* that you are seeing?) You want many slices, from many perspectives, and if possible, different time slices (seconds apart, months apart) so you can *figure out* what you are seeing. Figuring out is a matter of imaginative draftsmanship, so that once you have figured out what it is you are seeing, you can now account for how it appears in the various slices or aspects.

Displays and Figuring Out

In order to figure out what is going on, it is helpful to have a multi-image display or arrangement of photographs showing the variety of spatial and temporal perspectives and the variety of examples, the set of dense observations. You might *compare and contrast*, choosing some image or video for more careful study, but at first you have all the information in front of you. And from past experience, you have a sense of *what is more generally shown* in each slice.

For common problems, with ordinary presentations, you might be able to almost automatically label a phenomenon or provide a diagnosis, in effect confirming your immediate impression. But less common problems with idiosyncratic presentations demand a form of *exploratory analysis*. You are not yet looking for evidence of *X;* you are presented with lots of stuff and are not sure what is the evidence, what is less relevant, what is the *X*. That which is *obvious* is just what we do not normally examine since we claim to understand it already. But here we need to have our noses pushed into the messiness, again and again, insistently presenting the world back to ourselves, so that we see what is there in front of our noses even if we would otherwise claim to see it all.

Showing the World to Ourselves

In exploratory work *we are finding out about the world before we have been able to theorize it into abstraction*. We are testing informal notions of what is going on, hypotheses, as we try to figure out what we are seeing. Ideally, we begin to tell a story of what is going on, so replacing tentative interpretations with an objective world where each slice confirms that

story. Of course, we may be unable to tell such a fine story, and there will be leftover, unaccounted-for slices or details.

Urban tomography allows us to imagine ways of documenting a city in terms of multiple slices (*tomography*) in space and in time and in type, and so in terms of a unity or identity in that manifold or multiplicity of aspectival variations (a *phenomenology*, what phenomenologists call "eidetic variations"), showing how people, machinery, and nature work together or coordinate to get the city's work done (a *choreography*). If our knowledge of the world is as the world is *for us*, it is through urban tomography that such knowledge is evidenced. By filling in and figuring out, urban tomography leads to a fuller sense of place and activity and meaning.

Notes

Preface

1. R. Sokolowski, *Introduction to Phenomenology* (Cambridge: Cambridge University Press, 2000), is my source here, although this is not an exact quote.

2. Here the painter Courbet (1819–77) seems relevant: "Wherever I put myself is the same to me; it's always good, as long as one has nature under one's eyes." (quoted in M. Fried, *Courbet's Realism* [Chicago: University of Chicago Press, 1990], 281 for all quotes). Courbet also says, "What are points of view? Do points of view exist?" Then Fried says that "they [Courbet, Disdéri] dramatize a contrast between a representational attitude keyed to the depiction of one or another of an infinite number of possible fragmentary *views* of the world and an attitude that aims on the contrary to represent the world or say nature *as a whole*." Here realism is of necessity allegorical and metaphoric.

3. B. Rathbone, *Walker Evans: A Biography* (New York: Houghton Mifflin, 1995), 90. The title of Evans's first book is *American Photographs* (1938).

4. Besides Diderot, Marville, Atget, and Sander, I am thinking of Edward Tufte, Ed Ruscha, and Robbert Flick.

5. For my purposes, tomography is a mode of evidencing, providing "the truth of disclosure," to use Sokolowski's phrase (pp. 158–60). Alternatively, tomography might be employed to provide evidence *for* a generic or scientific claim, and so we might be concerned with matters of deception, misrepresentation, and validity—for which there exists a substantial scholarly literature in the social sciences. A good place to start is J. Collier and M. Collier, *Visual Anthropology: Photography as a Research Method* (Albuquerque, New Mexico: University of New Mexico Press, 1986).

Chapter 1

1. E. Daley, "Expanding the Concept of Literacy," *EDUCAUSE Review* (January 2003): 32–40. Within cinema studies, the nature of narrative itself (for example, database narrative and interactive media) is a major subject.

2. Charles Eames said something like this, but I do not have the reference.

3. "If the proof is said to reside in the pictures, the [skeptical] hearer assumes that those pictures must be exceptional. Such initial resistance [to the phenomenon] gives way . . . only to the cumulative impact of number. . . . How such superfluity is received depends less on the person than on the progress of persuasion. Readers in their skeptical phases will think half a hundred instances still too few. And once conviction has taken hold, more than six is too much. . . . But the glut of evidence is essential. It helps establish the subject as one concerned not with idiosyncrasies, but with a major phenomenon [for Steinberg] in historic Christianity. The present archive . . . keeps expanding because the material abounds" (L. Steinberg, *The Sexuality of Christ in Renaissance Art and in Modern Oblivion* [Chicago: University of Chicago Press, 1983, 1996], 109).

4. Camilo Vergara, *The New American Ghetto* (New Brunswick, N.J.: Rutgers University Press, 1995), illustrates some of the distinctive designs of storefront churches.

5. Sokolowski, *Introduction to Phenomenology*.

6. Such a manifold or multiplicity, what Tufte calls "small multiples," allows us to readily ask, "compared to what?" They provide "information slices . . . within an eyespan, and . . . uninterrupted visual meaning" (E. Tufte, *Envisioning Information* [Cheshire, Conn.: Graphics Press, 1990], chap. 4).

A hologram provides multiple *layers* of detail, initially the gross outline and then finer and finer details—a very different sort of tomography.

7. This is taken from an interview with Jonathan Miller: "I am absolutely fascinated by the fact that life is simply a tissue of negligible detail. When you heap them together and get them all right and have a mass of them, when the audience is there, they suddenly realize they've seen life. There isn't anything else to life" (*New York Times,* 7 October 2006, first page of the Arts section).

8. Daley, "Expanding the Concept of Literacy."

9. For my purposes, actual continuity matters, whether in space or in time or both, so conventional editing is not an option—the idiosyncratic or throwaway image may be telling; the boring or problematic visual or scene might be accompanied by useful audio. We prefer to have all the takes.

10. M. Krieger, M. Ra, J. Paek, R. Govindan, and J. Evans-Cowley, "Urban Tomography," *Journal of Urban Technology* 17 (2010): 21–36.

11. Eric Livingston has pointed out that those who work jigsaw puzzles do not treat the pieces as disjointed but as aspects of a whole (perhaps at various scales), whether or not they are given the picture of the put-together puzzle, for they have notions of border or of shared-color regions, and so forth. Hence, from Livingston's analysis of puzzles, or of chess, pieces are inevitably contextual, inevitably aspectual. See E. Livingston, *Ethnographies of Reason* (Aldershot, U.K.: Ashgate, 2008); E. Livingston, "Context and Detail in Studies of Witnessable Social Order: Puzzles, Maps, Checkers, and Geometry," *Journal of Pragmatics* 40 (2008): 840–62.

12. R. K. Wallace, *Frank Stella's Moby-Dick* (Ann Arbor: University of Michigan Press, 2000).

13. The following is from Jean Le Rond d'Alembert, *Preliminary Discourse to the Encyclopedia of Diderot*, tr. R. N. Schwab (originally in French, 1751; Chicago: University of Chicago Press, 1995), 122–27:

The section on the mechanical arts required no fewer details and no less care. . . . [E]verything impelled us to go directly to the workers.

We approached the most capable of them in Paris and in the realm. We

took the trouble of going into their shops, of questioning them, of writing at their dictation, of developing their thoughts and of drawing therefrom the terms peculiar to their professions, of setting up tables of these terms and of working out definitions for them, of conversing with those from whom we obtained memoranda, and (an almost indispensable precaution) of correcting through long and frequent conversations with others what some of them imperfectly, obscurely, and sometimes unreliably had explained. . . . We have seen some workers who have worked for forty years without knowing anything about their machines. With them, it was necessary to exercise the function in which Socrates gloried, the painful and delicate function of being midwife of the mind, *obstetrix animorum.*

. . . several times we had to get possession of the machines, to construct them, and to put a hand to the work . . . in order to learn how to teach others the way good specimens are made.

It is thus that we have become convinced of men's ignorance concerning most of the objects in this life and of the difficulty of overcoming that ignorance. . . . it is through the long-established habit of conversing with one another that the workers make themselves understood, and this is accomplished much more by the repetition of contingent actions than by the use of terms. In a workshop it is the moment that speaks, and not the artisan. . . .

But the general lack of experience, both in writing about the arts and in reading things written about them, makes it difficult to explain these things in an intelligible manner. From that problem is born the need for figures. . . . A glance at the object or at its picture tells more about it than a page of text.

We have sent designers [draftsmen?] to the workshops. We have made sketches of the machines and of the tools, omitting nothing that could present them distinctly to the viewer. . . .

Moreover, it is workmanship that makes the artisan, and it is not in books at all that one can learn to work by hand. In our Encyclopedia the artisan will find only some views which he would not perhaps ever have had and some observations which he would have made only after several years of work. We will offer to the studious reader, for the satisfaction of his curiosity, what he would have learned by watching an artisan operate, and to the artisan we will offer what one might hope he would learn from the philosopher in order to advance toward perfection. . . .

The quality of engraving will correspond to the perfection of the designs.

14. As for Atget, see D. Harris, *Eugène Atget, Unknown Paris* (New York: New Press, 2003), 11. On the commissioning and actual work in such surveys more generally, see R. Kelsey, *Archive Style, Photographs and Illustrations for U.S. Surveys, 1850–1890* (Berkeley: University of California Press, 2007). Harris, *Eugène Atget,* 22, proposes a likely strategy that Atget pursued in his sequences of photographs.

15. "Marville, a chaque carrefour, fait le tour de la place et prend, l'une après l'autre, les voies que se croisent. Si elles doivent disparaître sur toute leur longueur, souvent il avance et photographie la rue en sens inverse" (M. de Thézy, *Marville Paris* [Paris: Hazan, 1994], 31). However, unlike Atget, Marville only photographs the front of a shop or residence if it happens to be facing his camera (since it is on a cross street) as he is photographing down the street. Atget, on the other hand, provides detailed images of shops along the way.

16. "[O]ne might say that most photographers of Atget's time [the first quarter

of the twentieth century] believed, or felt, that the subject was a given, that its objective, public nature was clear and obvious. Most working photographers felt that it was their job to describe this objective thing and as precisely as possible. . . . to describe clearly and precisely what is in front of the camera, but what is out there now seems not secure and objective but contingent, provisional, relative, capable of continual speciation. . . . the endless plasticity of the world that enabled him [Atget] to return to the same motifs" (J. Szarkowski, *Atget* [New York: Museum of Modern Art, 2000], 16–17).

17. This is seen in the German New Objectivity (*Neue Sachlichkeit*, or New Vision) movement of the 1920s and 1930s (Karl Blossfeldt, Albert Renger-Patzsch). More recently, think of Bernd and Hilla Becher's images of industrial buildings on shadow-free overcast days. The *Neue Sachlichkeit* cataloged the world (botanical plants, industrial plants). It emphasized technical skill. It was committed to the theory of photography that goes with large-format "technical" photography. See for example the series of books about using Linhof cameras published by Grossbild: N. Karpf, *Linhof Practice* (Munich: Verlag Grossbild-Technik, 1959). Almost perversely, in the 1960s William Christenberry, artist and successor to Walker Evans, began his systematic photographing of southern United States vernacular buildings using a Brownie camera.

18. De Thézy, *Marville Paris*, 28ff.

19. I want to thank my many collaborators, listed at http://www.usc.edu/sppd/parismarville, for doing their best given my distant guidance provided through e-mail and attachments. City planners will appreciate how even iconic places change yet might remain much the same, even under major efforts at "urban renewal."

20. In the movie *The Bourne Ultimatum* (2007), the intelligence agency monitor directs the controllers of the various video cameras surveying London and the agents equipped with video cell phones to have "eyeballs on the street," as the agency is trying to track and observe Bourne.

21. Here, also, clock-time matters: electricity rates are lowest in the evening and in the middle of the night and early morning, and so an electrically powered furnace might well be operated mostly at those hours, the usual daytime work hours devoted to maintenance.

22. For most of my work I employed two cameras: the Hasselblad SWC (Super Wide C) "box camera" has a 38 mm f/4.5 Zeiss Biogon lens; and the Leica R8 single-lens-reflex camera is fitted with a 19 mm Leica Elmarit-R f/2.8 lens. (I also used a Contax G2, mostly fitted with a 21 mm Biogon f/2.8 lens.) The Biogons and the Elmarit are each slightly less than one-half the focal length of the standard "normal" lens (defined by the diagonal of the negative) for their respective negatives of 2¼ × 2¼ inches (actually 57 × 57 mm) and 24 × 36 mm. Hence they are very wide-angle lenses. Both lenses are of very high definition, all over the negative; they show comparatively little falloff of illumination toward the edges and corners; and they have low distortion (straight lines stay straight).

The Zeiss Biogon has been described as follows (by the photographer Lee Friedlander):

I was having some kind of congenital problem with wide-angle lenses [on the 35 mm camera he used, a Leica range-finder camera] in the desert, probably because of the light, and probably because those lenses were designed for flat surfaces. Those lenses are usually used by people who do architectural work, which deals with flat surfaces, not so much with large area with lots of

details. I don't know what the reasons were. It looked as if areas were out of focus and they wouldn't be the same every time. I call it congenital because it comes with the lens; it's not something anybody can fix and it's not that anybody even knows why. . . . [Asking people what is the best wide-angle lens they know of] The common denominator was the Hasselblad SWC. The Hasselblad SWC is really a very primitive piece of equipment, . . . it's really a fancy box camera, it has no rangefinder, it has no meter, . . . it's a lens on a back. . . . the lens didn't have any problems in the desert. . . . With the square [shape of the negative] . . . I was able to get more sky. . . . I always wanted more sky out of a horizontal picture. All of a sudden the whole tree is in the picture. (in P. Lambert, ed., *Viewing Olmsted* [Cambridge: MIT Press, 1997], 108–9)

I suspect that the problem Friedlander refers to concerns the ability of a lens to distinguish or resolve very fine detail (vs. its ability to have high contrast and sharp edges, which is about its ability to distinguish somewhat less fine detail). Another possibility lies in the lens designers' choice of plane of focus—chosen for highest resolution (of very fine detail) or for highest contrast (of somewhat less fine detail, the edges of objects). The resolution and contrast of this Hasselblad-Zeiss lens are both quite high already. One other concern might be the capacity of the lens (and film) to register fine differences in tonality and hence of luminances and so indicate shapes and texture from shading. Erwin Puts's Web postings are helpful in thinking about these issues: www.imx.nl/photo. His *Leica Lens Compendium* (East Sussex, UK: Hove, 2003), newly revised, is announced on the site.

If I photograph the same storefront facades with an ordinary or "normal" lens and with Polaroid integral film (as in the SX-70 system), I discover how much is in the way, for I have to get further back from the building in order to incorporate the facade (I am now in the middle of the street). Yet the comparatively low resolution of the Polaroid system (~6 line-pairs/mm, compared to, say, 40–80 line-pairs/mm of conventional negative films) means that detail is obviously lost. Getting a bit closer to the Polaroid print reveals that.

It does matter that I am using a wide-angle lens and a fine-resolution lens-film system.

There is another advantage to a wide-angle lens, unobtrusiveness:

The ordinary encounters of everyday street life can be filmed quite unobtrusively. One way is to shoot from afar with a telephoto lens. This perspective is all right for tracking shots and pedestrian flows. But it is all-wrong for most street activity. For that you should get up close, and the closer the better. Facial expressions, hand gestures, feet movements: you want to move in for these. The problem, of course, is to do this without your subjects' being aware of your interest. But on a busy street they usually pay you no heed. To keep it that way, I find that it is important not to hold the camera up to eye level and point it at them. I mount a spirit level atop my cine cameras. If I look down at it, the camera cradled in my arms, I can be reasonably sure the subjects are properly framed. I use a very wide angle lens to assure this—and to give me enough depth of field for good focus. (W. H. Whyte, *City: Rediscovering the Center* [New York: Doubleday, 1988], 350)

23. See, for example, E. Ruscha, *Every Building on the Sunset Strip* (Los Angeles: 1966); and Ed Ruscha, *Then & Now* (Göttingen: Steidl, 2005). J. T. Murray and

K. L. Murray, *Store Front: The Disappearing Face of New York* (Corte Madera, Calif.: Gingko, 2009), is a recent effort in this vein.

24. "[Still] In making a landscape we must withdraw a *certain distance*—far enough to detach ourselves from the immediate presence of other people (figures), but not so far as to lose the ability to distinguish them as agents in a social space. Or, more accurately, it is just at the point where we begin to lose sight of the figures as agents, that landscape crystallizes as a genre. . . . [L]andscape as a genre is involved with making visible the distances we must maintain between ourselves in order that we may recognize each other for what, under constantly varying conditions, we appear to be. It is only at a certain distance (and from a certain angle) that we can recognize the character of the communal life of the individual—or the communal reality of those who appear so convincingly under other conditions to be individuals" (Jeff Wall, *Landscapes and Other Pictures* [Wolfsburg: Kunstmuseum Wolfsburg, Cantz, 1996], 11–12).

25. Note that the larger negative of the Hasselblad SWC does that much more effectively than the smaller Leica 35 mm negative, were they fit with lenses that give roughly the same angle of view. In addition, according to the Zeiss designers of the lens,

> At Zeiss, we see the Biogon 4.5/38 as a documentation tool, able to record as many details as possible regardless of the position within the frame. As such, we want the Biogon 38 to deliver even performance over the entire frame. With the new version of the Biogon in the Hasselblad SWC 905, we were able to increase the performance in the corner, at a very slight expense in the center, compared to the previous version as used in the SWC 903. This expense is most probably unnoticeable in practical photography, given the resolving power of color film with its limits far lower than the Biogon's.
>
> This is what I achieved with my SWC 903 in terms of resolution (using Agfa APX 25 B&W film, which resolves up to 200 linepairs per millimeter): Center: 200 linepairs per millimeter [the human eye resolves about 6–8 line-pairs/millimeter under good conditions; the resolution figures for film are probably for 1% discrimination; dividing them by about five gives something to compare to the eye; and, dividing by 5 again for enlargement gives 8 line-pairs/mm in an enlarged picture], Edge: around 140, Corner: 100. For comparison: The color film with highest resolving power, Fuji Velvia, achieves no more than 160. Kodak Ektachrome types achieve around 130. If we now resolve more in the corners, and slightly less in the center, Fuji Velvia will only benefit from the improvement in the corner, not losing anything in the center.
>
> While for most photographers, sharpness may not even be different between the two versions of the SWC, one aspect is visibly better with the new 905 version: stray light suppression [flare] is clearly improved over the 903. (Kornelius J. Fleischer, "Subject: Response to, Is New Hasselblad 905SWC as Good as 903SWC?," posting date: 2001-12-03, Medium Format Forum on the Internet site photo.net)

The square image makes maximal use of the lens's capacities, and those capacities almost always exceed the needs of the image. Even then, flare suppression (and so contrast and detail) are crucially improvable. But once the technology is adequate, it is forgotten in the process of imaging and investigation.

Such loving and detailed descriptions of technologies are perhaps not surprising. The limits of the technologies set the boundaries of discovery in the field.

26. Annette Insdorf, *François Truffaut* (1978; Cambridge: Cambridge University Press, 1994), 70.

27. I am not concerned with composition, a decisive moment, aesthetics, or with "how the world looks as it is photographed" (Garry Winogrand), or even with Lee Friedlander's wonderful approach. Not so much, even, the tradition of urban photography—except to learn methods and techniques and schemes.

Peter Hales has argued that photography in the nineteenth and early twentieth centuries made the American city comprehensible, so controlling its complexity and disturbingness for a country used to an agrarian ideal. In effect, photography domesticated the urban frontier, making a peace with urbanization and industrialization. Early on, it is a "grand style" which celebrates the city; later (Jacob Riis) it is a reform style, one that implies that things could be gotten in order, that there is no deeper problem, that reform is enough. By about 1920 the photograph itself is the thing of interest, not the city. But then in the Farm Security Administration (FSA) photographs, the city and the photograph become identified through the photo-documentation project supervised by Roy Stryker and Rexford Tugwell. Even rural life is to be viewed from the perspective of the urban metropolis. See P. Hales, *Silver Cities* (Philadelphia: Temple University Press, 1984). Perhaps the tradition of photography is urban and city presenting and city preserving, reflecting the coincidence of industrialization, urbanization, and photography.

The FSA sort of documentation is not an idiosyncrasy. The Mass Observation movement in Britain (1937–43) had similar goals. See G. Cross, ed., *Worktowners at Blackpool: Mass-Observation and Popular Leisure in the 1930s* (London: Routledge, 1990). The introduction reviews the history of Mass Observation and provides references to the published literature by and about it. The Mass Observation Archive at the University of Sussex continues this work: http://www.massobs.org.uk

Martha Rosler, *3 Works, Critical Essays on Photography and Photographs* (Halifax: Press of the Nova Scotia College of Art and Design, 1981), 71–86, argues the antirevolutionary import of documentary photography.

28. Steinberg, *Sexuality of Christ.* See note 3 above.

29. See L. Friedlander, *Sticks and Stones: Architectural America* (New York: Fraenkel Gallery and Distributed Art Publishers, 2004).

Chapter 2

1. Greg Hise was my guide throughout this process from the very beginning, he and his work pointing me to sites and areas and confirming my own finds. My introduction was G. Hise, " 'Nature's Workshop': Industry and Urban Expansion in Southern California, 1900–1950," *Journal of Historical Geography* 27 (2001): 74–92. See, more recently, Hise's "Industry, Political Alliances and the Regulation of Urban Space in Los Angeles," *Urban History* 36 (2009): 473–97.

Although there are recurrent attempts to clean up Los Angeles and some urban renewal, there really has been no Haussmann or Robert Moses (but, infamously, Chavez Ravine). W. Deverell, *Whitewashed Adobe: The Rise of Los Angeles and the Remaking of Its Mexican Past* (Berkeley: University of California Press, 2005), describes one sort of "renewal."

2. The Detroit Industrial Murals by Diego Rivera (1933) display all of the essential processes of the Second Industrial Revolution, and in a panoply that might

well be described as tomographic. They were commissioned by Edsel Ford. L. B. Downs, *Diego Rivera: The Detroit Industrial Murals* (New York: W. W. Norton, 1999).

3. Hise's quote is from an unpublished manuscript, part of a book project, "Industrial Los Angeles."

4. R. Lewis, *Manufacturing Montreal: The Making of an Industrial Landscape, 1850–1930* (Baltimore, Md.: Johns Hopkins University Press, 2000).

5. This is a recurrent theme in Lewis, *Manufacturing Montreal.*

Chapter 3

1. D'Alembert, *Preliminary Discourse to the Encyclopedia of Diderot*, 122, 123, 124, 126. See Chapter 1, note 13, for a fuller quotation.

2. For example, Friedlander was commissioned by Cray Research to photograph people at work at the firm. See *Cray at Chippewa Falls, Photographs by Lee Friedlander* (Minneapolis: Cray Research, 1987). See also Bill Bamberger and Cathy N. Davidson, *Closing: The Life and Death of an American Factory* (New York: Norton, 1998).

3. From an unpublished manuscript of Greg Hise.

4. Together, *On the Waterfront* (1954, which starred Marlon Brando); Allan Sekula's *Fish Story* (Richter Verlag, 1996), a book of photographs and analysis; and Sebastião Salgado's and Edward Burtynsky's photographs of ship-breaking are a requiem and a critique of the contemporary infrastructure of shipping. Frank Stella's series of artworks keyed to *Moby-Dick* (1986–97) are effectively a celebration of a past infrastructure. See Wallace, *Frank Stella's Moby-Dick.*

5. See Wall, *Landscapes.* See Chapter 1, note 24, for the relevant quotation.

6. The Department of Labor, now following the new North American Industrial Classification System (NAICS), rather than the older Standard Industrial Classification (SIC) codes, now classes publishing as "information," not manufacturing. The President's Council of Economic Advisors wonders if McDonald's is a manufacturing industry rather than a service industry.

7. Eric Livingston's work in ethnomethodology has deeply influenced my thinking here. For example, he says, "In our driving, we work with other drivers, usually in an anonymous fashion, to produce the ordinary conditions of driving that let us drive together" (Livingston, *Ethnographies of Reason*, 211).

The discussion of choreography does not diminish the importance of just picturing the actual dance or work. It is a discovery to show the work or the worship itself, since few enter into those worlds who are not directly involved in doing the work or the worship. As for the visual documentation of dance, see J. Mitoma, E. Zimmer, and D. A. Stieber, *Envisioning Dance on Film and Video* (New York: Routledge, 2002).

8. *Westways* (Automobile Club of Southern Calif.) 99 (January 2007): 48.

9. R. Waldinger and M. I. Lichter, *How the Other Half Works* (Berkeley: University of California Press, 2003).

10. E. Puts, *Leica R-Lenses*, chap. 6: "15mm Lens" (November 2003), 6, available at en.leica-camera.com/assets/file/download.php?filename=file_1875.pdf. There is perhaps some conflict here between Jeff Wall's description of landscape (Chapter 1, note 24) and Puts's, for Puts contrasts the smaller figures in the field vs. the larger figures close up. This may be a matter of different sorts of photographic practice: art photography vs. photojournalism. But it is also true that some indoor landscapes fulfill Wall's account, while others fulfill Puts's.

11. The language here is taken from E. Puts, *Leica Lens Compendium.* Many of these descriptions depend on the fact that the image is in landscape (or horizontal) format. In portrait (or vertical) format, especially in 35 mm where the aspect ratio is 3:2, new phenomena may include the depth in the background that now will be included, the ceiling itself or more of the floor.

12. Digital camera sensors cut off resolution much more sharply (at the Nyquist spatial-frequency) than does film, but digital sensors may actually provide superior resolution until close to the cutoff. For most digital cameras, the sensors and lenses provide much less resolution at higher-spatial frequencies than does film and a high-quality prime lens (again, the Nyquist limit for digital sensors). Film's greater spatial resolution can still be buried under camera shake, poor focusing, or imprecise chemical processes. Digital sensor capacities for unsharp masking may allow for sharper images (comparatively low spatial frequencies), which, however, have much less very fine detail (much higher spatial frequencies).

13. We might describe the relationship of the dance to the choreography as the relationship of photodocumentation or photojournalism to ethnography and urban tomography.

Chapter 4

1. Here I partially quote or paraphrase from G. Hise, "Architecture as State Building," *Journal of the Society of Architectural Historians* 67 (2008): 173–77.

2. In contrast, the electricity-distributing stations for New York City's subways often look like small office or manufacturing buildings. See C. Payne, *New York's Forgotten Substations* (New York: Princeton Architectural Press, 2002).

3. This term of art is due to Shklovskii. "Estrangement" is another possible translation. "The technique of art is to make objects 'unfamiliar,' to make forms difficult, to increase the difficulty and length of perception because the process of perception is an aesthetic end in itself and must be prolonged. *Art is a way of experiencing the artfulness of an object; the object is not important*" (V. Shklovskii, "Art as Technique" [1917], in L. T. Lemon and J. T. Reis, *Russian Formalist Criticism: Four Essays* [Lincoln, Nebraska: University of Nebraska Press, 1965], 12). However, unlike Shklovskii, in the end I am interested in the object.

4. See the work of Stanley Greenberg, *Invisible New York* (Baltimore, Md.: Johns Hopkins University Press, 1998); and Jet Lowe, *Industrial Eye* (Washington, D.C.: Preservation Press, 1986).

5. For more on electrification, see T. P. Hughes, *Networks of Power* (Baltimore, Md.: Johns Hopkins University Press, 1983), as well as biographies of Thomas Edison. In 1954, Francis Ponge wrote a paean to electricity, "Texte sur Electricité," in *Lyres* (1967; Paris: Gallimard, 1980); original French text translated into English in S. Gavronsky, trans., *The Power of Language* (Berkeley: University of California Press, 1979), 156–213. This work was commissioned by the French electricity company to encourage architects to make provision in their designs for electric outlets, etc. Also see J. Cole, *The Magic Schoolbus and the Electric Field Trip* (New York: Scholastic, 1999). I have found E. B. Kurtz, T. M. Shoemaker, and J. E. Mack, *Lineman's and Cableman's Handbook* (New York: McGraw-Hill, 1997), to be useful. Steve Erie's work on Los Angeles's infrastructural "jewels," *Globalizing LA* (Stanford, Calif.: Stanford University Press, 2004), is very helpful. On the insides of infrastructure, see Greenberg, *Invisible New York;* and Lowe, *Industrial Eye.* See also

J. L. Brigham, *Empowering the West: Electrical Politics before FDR* (Lawrence: University Press of Kansas, 1998); and M. W. Roth, "IA and the 20th Century City: Who Will Love the Alameda Corridor?," *Industrial Archaeology* 26 (2000): 71–84.

6. This section draws directly from M. H. Krieger, "The City-Inscribed and the City-Natural—At Your Feet," *Journal of Planning Education and Research* 29 (2010): 491–493. Earlier papers in this series include M. H. Krieger, R. Govindan, M. Ra, and J. Paek, "Pervasive Urban Media Documentation," *Journal of Planning Education and Research* 29 (2009): 114–16; M. H. Krieger and T. Holman, "A Dozen 'Tamales!': Documenting the Aural Urban Sensorium," *Journal of Planning Education and Research* 27 (Winter 2007): 228–30, audio supplement at http://jpe.sagepub.com/content/vol27/issue2/images/data/228/DC1/T44.mp3; and M. H. Krieger, "Taking Pictures in the City," *Journal of Planning Education and Research* 24 (2004): 213–15. Somewhat earlier is M. H. Krieger, "Truth and Pictures," in Jon Wagner, ed., *Images of Information: Still Photography in the Social Sciences* (Beverly Hills, Calif.: Sage Publications, 1979), 249-57.

Chapter 5

1. I am not sure that these images are religious images, as understood by those who write about the visual culture of religion. Surely they are about the seeable aspects of religious life. I think they are about "visual piety," as understood practically by the congregants of each church. See D. Morgan, *Visual Piety* (Berkeley: University of California Press, 1998). We might say that here visual piety meets mundane city life and the material artifacts of past economies.

2. G. Wacker, *Heaven Below: Early Pentecostals and American Culture* (Cambridge, Mass.: Harvard University Press, 2001). See also F. Kostarelos, *Feeling the Spirit: Faith and Hope in an Evangelical Black Storefront Church* (Columbia: University of South Carolina Press, 1995); O. McRoberts, *Streets of Glory* (Chicago: University of Chicago Press, 2003).

3. C. McWilliams, *Southern California: An Island on the Land* (1946; Salt Lake City: Peregrine Smith, 1973), chap. 13, provides popular accounts for why Southern California has so many "cults": it is an incubator of creeds; the weather is good, so people have time to meditate; it is the westernmost part of the continental United States, and there is no place else to go; and immigrants here are at loose ends, and there are lots of those immigrants.

4. Classifications of some Protestant denominations, from J. G. Melton, *Encyclopedia of American Religion*, 4th ed. (Detroit: Gale, 1993), include the following: Pietist-Methodist Family; Holiness Family; Pentecostal Family (White Trinitarian Holiness Pentecostals, White Trinitarian Pentecostals, Deliverance Pentecostals, Apostolic Pentecostals, Black Trinitarian Pentecostals, Signs Pentecostals, Spanish-Speaking Pentecostals, Latter Rain Pentecostals, Other Pentecostals); European Free-Church Family; Baptist Family (Calvinist Missionary Baptists, Primitive Baptists, Black Baptists, General Baptists, Seventh Day Baptists, Christian Church); Independent Fundamentalist Family; Adventist Family.

Denominations listed in the *Greater Los Angeles Telephone Directory Yellow Pages* ("Pacific Bell Smart Yellow Pages, Keep until August 2001") follow. Note that the heading "Mosques" has no subheads; "Religious Organizations" has no subheads but does include some churches. Churches of different denominations have distinct Standard Industry Codes, and these are indicated in the computerized telephone directory *Acxiom Biz*.

The following are listed under "Churches": Adventist Christian; African Methodist Episcopal; Anglican; Apostolic; Armenian; Armenian Apostolic; Assemblies of God; Assemblies of God, Independent; Baha'i; Baptist; Baptist-American; Baptist, Bible Fellowship; Baptist Conservative; Baptist-Free Will; Baptist, General; Baptist-Independent; Baptist, Independent Fundamental; Baptist-Missionary; Baptist Southern; Bible; Bible Methodist; Bible Missionary; Brethren; Buddhist; Catholic American; Catholic, Byzantine; Catholic, Eastern; Catholic, Ecumenical; Catholic, Roman; Catholic, Traditional; Charismatic; Christian; Christian Disciples; Christian-Disciples of Christ; Christian Evangelical of America; Christian Evangelistic; Christian Methodist Episcopal; Christian & Missionary Alliance; Christian Reformed; Christian Science; Church of Christ; Church of Christ Holiness; Church of God; Church of God—Anderson Indiana Affiliates; Church of God in Christ; Church of God—Seventh Day; Church of Jesus Christ of Latter-day Saints, The; Community; Congregational; Cosmology, Ontology & Metaphysics; Covenant; Episcopal; Episcopal-Anglican; Evangelical; Evangelical Free; Evangelical Methodist; Foursquare Gospel; Free Methodist; Friends; Full Gospel; Gnostic; Gospel of Christ; Independent Bible; Independent Fundamental; Interdenominational; Jehovah's Christian Witnesses; Jehovah's Witnesses; Jewish Messianic; Korean Methodist; Lutheran; Lutheran-ELCA; Mennonite; Mennonite Brethren; Metaphysical Christianity; Metropolitan Community; Missionary; Moslem Mosque; Nazarene; New Testament; New Thought; Non Denominational; Old Catholic; Orthodox Catholic; Orthodox Eastern; Pentecostal; Pentecostal Church of God; Pentecostal Holiness; Pentecostal-United; Polish National Catholic; Presbyterian, Bible; Presbyterian Church In America; Presbyterian, Evangelical; Presbyterian, Korean Western; Presbyterian, Orthodox; Presbyterian, Reformed Evangelical Synod; Presbyterian Unaffiliated; Presbyterian (U.S.A.); Reformed in America; Reformed Presbyterian; Religious Science; Rescue Missions; Salvation Army; Science of Mind; Self-Realization Fellowship; Seventh-day Adventist; Seventh Day Adventist Reform Movement; Seventh Day Baptist; Sikh; Spiritual Science; Spiritualist; Swedenborgian; The Church of Jesus Christ; Theosophy; Unitarian Universalist; United Church of Christ; United Methodist; Universal Life; Universal Religion; Various Denominations; Vedanta; Wesleyan; Word of Faith.

The following are listed under "Synagogues": Synagogues; Conservative-United Synagogue of America.

Denominational and theological terms include the following (the terms are italicized): *Aish HaTorah*—*Aish* means fire in Hebrew, and here the statement is that the Torah is like fire, converting the material world into transcendent energy. *Alpha and Omega*—Black Trinitarian Pentecostal, Rev. 1:8, 21:6. *Agape*—love, often used by Orthodox churches, John 3:16. *Antioch*—ancient capital of Syria; the first gentile church, and the first place where disciples were called "Christians"; often employed by Orthodox churches. *Apostolic*—referring to the Apostles' Pentecost (after the Pesach, and the crucifixion), when they received the Holy Spirit. *Assembly of God*—a two-step denomination (no sanctification), founded 1914. *Bethany*—village associated with the last days of Jesus. *Bethel*—Bible school in Topeka, Kansas, where in December 1900 there were vivid experiences of speaking in tongues. *Casa de Oracion*—House of Prayer. *Calvary*—place of Jesus' crucifixion. *Church of God in Christ*—African American denomination; founded originally as Holiness in 1895 and became Pentecostal in 1907. *Church of the Nazarene*—Holiness denomination following early Methodism, but not Pentecostal; founded in 1908. *Defenders of the Faith*—Hispanic Pentecostal.

Ebenezer—stone of help. *Eliam*—one of David's warriors, father of Bath Sheba. *Elim*—Israelites' encampment after crossing the Red Sea; also means strong tree; White Trinitarian Pentecostal, much like Assembly of God, Exod. 15:27, Num. 33:9. *Esmirna*—Smyrna, Rev. 2:8–11. *Foursquare*—International Church of the Foursquare Gospel, a two-step church founded (c. 1920) by Aimee Semple Macpherson; the four precepts are conversion, physical healing, second coming, and redemption. *Full Gospel*—Fellowship of Churches and Ministries (apostolic). *Gethsemane*—place of the agony preceding the crucifixion. *Jesus Only*—Apostolic and Pentecostal but Oneness (vs. Trinitarian), e.g., United Pentecostal Church. *Kedron*—a place crossed by Jesus on the way to Gethsemane. *Latter Rain*—the coming of the apocalypse, Hosea 6:3. *Lilly of the Valley*—God's love, Song of Sol. 2:1. *Macedonia*—referring to fourth-century patriarch of Eastern Church, Constantinople, Macedonius, who taught that the Holy Spirit is a creature like the angels and was a servant and minister of Father and Son. *Mahanaim*—God's camp, Gen. 32:1,2. *Manantiales*—springs, sources, Prov. 4:23. *Maranatha*—Our Lord, come! [Marana tha = Our Lord, come!] 1 Cor. 16:22, Eph. 4:1. *MBC*—Missionary Baptist Church; often this is an unaffiliated congregation (perhaps indicating a theological doctrine that they are independent of man-made associations); also, a denomination (National Missionary Baptist Convention, named such in 1988). *M. I.*—Iglesia de Dios Pentecostal, Movimiento Internacional, founded in 1916 in Puerto Rico. *Peniel*—face of God, Gen. 32:30 or 31 (Masoretic). *Praise Chapel*—Praise Chapel Churches and Ministries, fellowship of heart not structure, emphasis on Holy Spirit. *Religious Science*—the trademarked Science of Mind philosophy, claiming to combine science and religion. *Rhema*—revelation, direct and meaningful word (Rhema Bible Institute). *Shabbach*—shout, praise, Pss. 63:3, 100:4. *Shaddai*—God Almighty. *Shalom*—peace, welcome. *Shekinah*—God present among us. *Shiloh*—an early Israelite military and religious center, later suffering disaster and symbolizing desolation, Gen. 49:10, in which shai-loh may be taken to mean "tribute to him"; the passage is taken to read as a reference to Jesus' coming. *Seventh-Day . . .* —Sabbatarians. *United Pentecostal Church*—a Jesus-only denomination. *Wesleyan*—referring to a founder of Methodism, John Wesley (d. 1791), and his brother Charles; it is an Arminian (vs. Calvinist) Methodism.

5. The scriptural references are drawn from references and quotations found on the signs and storefronts and from standard discussions of Pentecostalism. Some are used frequently, other just one time. I have given the Spanish titles of the books of the Bible if that is how I encountered them, and the same for the abbreviations. Some of the quotes are not unusual in their Christian meaning, but for the others, two themes stand out. The Holy Spirit, its powers and salvific purposes, and baptism of the Holy Spirit (a second baptism) appear again and again. The second theme is speaking in tongues, snake handling, and healing as signs of that second baptism. Joel's prophecy seems to be the crucial pretext: Even on the male and female slaves in those days, I will pour out my spirit (Joel 2:29). Starred passages appear in texts about Pentecostalism, although I have not yet observed them on a church.

The passages are from the following: Acts (Hechos) 2:38, 2:39, 2:42, 16:31; *Acts 2:1–4; *Col. 2:11; *1 Cor. 2:10, 12:3, 12:13, 13:1–3; 14:5; 2 Cor. 2:15, 5:7; Deut. 5:7, 8:18; *Eph. 1:13; Eph. (Ef.) 2:20, 4:5; Exod. 3:14, 17:15; Gal. 5:22, 5:35; Gen. 32:1, 2; Heb. 11:1, 12:14, 13:8; Isa. 26:2; Jer. 29:11; *Joel 2:29 (in the Masoretic text, it is Joel 3:2); *1 John 3:2; John (Juan) 3:14–15, 3:16, 7:38, 8:32, 14:6, 15:13, 17:21, but cf. Isa. 44:3, 55:1; Josh. 1:5; Mark 16:15, 17–18, 9:23; Matt. 1:23,

5:18, 11:28; 1 Pet. 2:5; Prov. 18:24; Ps. (Salmo) 24:10, 23; Rev. 22:17; Song of Sol. (Cantares) 2:1; 2 Tim. 2:15.

6. These are some of the symbols found on the storefronts, with conventional meanings for some of them. The likely meanings of each symbol are tied to the interpretation of relevant scriptural passages. There is no simple one-to-one code here. A symbol is the occasion for homily. The symbols are as follows: *Book*—Scripture; *Clouds*—heavenly source of rain; *Cross, Empty*—Christ risen and triumphant; *Cross and Crown*—Christ's victory; *Cross and Fire, Cross on a Globe*—M.I. (Movimiento Internacional); *Crown*; *Dove*—Holy Spirit, peace; *Eagle*—fostering of young (Exod. 19:4); *Eye*—apprehending divine revelation; *Fire*; *Fish*—*Ichthios* is an acronym for a confessional of Christian faith; *Foursquare Symbols*: cross, dove, cup, crown refer to Christ as Savior, Healer, Baptizer, and Soon to be King, respectively; *Handshake*—brotherhood, Jesus as Savior, United Methodist Church (Evangelical United Brethren); *Hand in Cloud*—first person of the Trinity, Moses parting the water; *Rain*—water, redemption?; *Sheep*; *Star of David*.

7. But I take some support from the writer and photographer Wright Morris:

> It is my feeling that the absence of people in these photographs [by Morris, in his photographs] enhances their presence in the objects—the structures, the artifacts, even the landscape suggests its appropriate inhabitant.
>
> This non-personal but commonly shared impression, giving rise to our larger sense of shared experience, is what I find and value in these salvaged fragments of the American past. The voice of the social commentator, frequently shrill and insistent, is not the one to which I am listening. These are not documents of social relevance [here, I do not agree with Morris, at all]; they are portraits of what still persists after social relevance is forgotten. Having escaped obliteration by time and progress, some artifacts are in fear of becoming antiques. This might be described as their death after life. (W. Morris, *Structures and Artifacts: Photographs 1933–1944* [Lincoln: Sheldon Museum of Art Gallery, University of Nebraska, 1975], 4)

8. New Revised Standard Version.

9. J. Creech, "Visions of Glory: The Place of the Azusa Street Revival in Pentecostal History," *Church History* 65 (1996): 405–24, points out the many other sources and flows into Pentecostalism. And, of course, there were many earlier moments signified by healings and speaking in tongues, and in many other places. For example, the Molokans (a sect out of Russia that permitted drinking milk during Lent), having come to America to escape persecution of Armenians, thought they had precedence. They were antiritualistic, gave authority to the Bible, and thought of themselves as Spiritual Christians.

10. R. L. Boyd, "The Storefront Church Ministry in African American Communities of the Urban North during the Great Migration: The Making of an Ethic Niche," *Social Science Journal* 35 (1998): 319–32. See also Kostarelos, *Feeling the Spirit*.

11. Other migrants were drawn to Islam, which again provided a closer-knit, less hierarchical and less dogmatic Abrahamic community. Moslems, African American and otherwise, created storefront mosques to mirror their previous sites of worship.

12. L. Albacete, "America's Hispanic Future," *New York Times,* 19 June 2001, A27. Albacete distinguishes Iberian Catholicism from Anglo Protestantism, in his

account the former being the home of an inclusive social doctrine, the latter being the home of alienated individualism.

13. M. Schapiro, *Words and Pictures* (The Hague: Mouton, 1973).

14. Meyer Schapiro has written eloquently about script in painting, especially how the Bible appears, as a book or as a scroll—whether it is being read by someone in the painting or it is held up so that the viewer can read it, and again sometimes the text is a squiggle. See M. Schapiro, "Script in Pictures: Semiotics of Visual Language," in *Words, Script, and Pictures: Semiotics of Visual Language* (New York: Braziller, 1996), 115–98.

15. D. Maldonado, Jr., ed., *Protestantes/Protestants: Hispanic Christianity in Mainline Traditions* (Nashville: Abbington Press, 1999).

16. Steinberg, *Sexuality of Christ*, 220, 251, refers to "textism" as an alternative position.

17. Vergara, *New American Ghetto*; T. Roma, *Come Sunday* (New York: Museum of Modern Art, 1996); T. Roma, *Sanctuary* (Baltimore, Md.: Johns Hopkins University Press, 2002). J. Berndt has photographed in Los Angeles for the Center for Religion and Civic Culture at the University of Southern California.

18. Put differently, in terms that might appeal to medieval and early modern religious thought, a church is a symbol of God's providence and presence in the world, its reality being just this symbolic transcendent content. "As the 'symbol of the kingdom of God on earth,' the cathedral gazed down upon the city and its population, transcending all other concerns of life as it transcended all its physical dimensions. . . . For us [moderns] the symbol is an image that invests physical reality with poetical meaning. For medieval man, the physical world as we understand it has no reality except as a symbol. . . . [F]or medieval man what we would call symbol is the only objectively valid definition of reality" (O. von Simson, *The Gothic Cathedral: Origins of Gothic Architecture and the Medieval Concept of Order* [Princeton, N.J.: Princeton University Press, 1956, 1962, 1988], xix).

Exod. 25–27's extensive albeit incomplete description of the ark has led many to be concerned with the symbolic or scriptural reference of its features. But Maimonides suggested that the ark was meant to "wean the Israelites from idolatrous worship and turn them toward God. . . . molding the Chosen People for its spiritual mission. . . . It kept before them that God was in their midst. . . . As God was holy and as the Sanctuary was holy, so must the Israelites make the sanctification of their lives the aim of all endeavors" (J. H. Hertz, ed., *Pentateuch and Haftorahs*, 2nd ed. [London: Soncino Press, 1985], 325). Worship and sanctity, an actual lived life in a place, makes it transcendent for us.

The photographs are not meant to affirm the sacred transcendence and aura of these places, but to present these places as those who worship there might see them. In their worship they so may make a claim. Diane Hagaman, a photojournalist turned social researcher, did not want to make photographs "loaded with the holy aura of spirituality" in her pictures of homeless shelters run by churches. She wanted to dissociate the ritual and power of religiously run homeless shelters from the sacred. She wanted to present the mundane aspects visually, so you could appreciate the power and control the institutions exercise. For example, she wanted to be sure that the source of illumination in the photographs was pictured, so that it was not taken to come from God. See D. Hagaman, *How I Learned Not to Be a Photojournalist* (Lexington: University Press of Kentucky, 1996), 40.

19. Physical Science Study Committee, *Physics*, 2nd ed. (Lexington, Mass.: D. C. Heath, 1965).

20. Note that the photograph itself is almost always seen in reproduction, surely

in this book but also most of the time. The quality of that reproduction can be very high, and it has been argued by Richard Benson that with multilayer (various shades of black or gray ink) offset lithography, that quality can be greater than that of the original print. See R. Benson, "An Artist's Perspective on the Photomechanical Alternative to Silver," in A. Beloili, ed., *Photography: Discovery and Invention* (Malibu, Calif.: J. P. Getty Museum, 1990), 109–16; and R. Benson, *The Printed Picture* (New York: Museum of Modern Art, 2009).

21. Walker Evans, interview by Leslie Katz, in P. Petruck, *The Camera Viewed*, vol. 1 (New York: Dutton, 1979), 128 (originally *Art in America*, 1971).

22. W. Evans, "Beauty of the Common Tool," *Fortune* (July 1955): 103–7.

23. L. Steinberg, *Leonardo's Incessant Last Supper* (New York: Zone Books, 2001), quoted on 28.

24. V.-L. Webb, *Perfect Documents: Walker Evans and African Art* (New York: Metropolitan Museum of Art, 2000), 34. Also, "His method of moving in close, reframing the subject in an often parallel placement to the edge of the negative, and cropping the print to obtain a tight, airless space around the subject is seen in this early commission. . . . A similar compressed space is seen in photographs made in 1933 of Jennings's carriages. . . . The frontal, parallel positioning of the camera angle and the center eye level of the nearly square print are similar in style to photographs in the African portfolio" (33).

25. D. Kirkpatrick, "Religious Photography in the Victorian Age," *Michigan Quarterly Review* 22 (1983): 335–50.

26. Again (see note 20 above), modern methods may well produce plates and printing of remarkable quality and originality. Here I am thinking of Richard Benson's work using the tritone process (three printing inks, black and two grays, for monochromatic ["black-and-white"] images). See C. Tompkins's article on Benson, "A Single Person Making a Single Thing," *New Yorker* 66 (17 December 1990): 44–52ff.

27. P. Galassi, *Walker Evans and Company* (New York: Museum of Modern Art, 2000), 19. Galassi suggests that the book is an ideal enclosure for such an aggregation, a book that may be printed by letterpress, gravure, or offset lithography. Gravure usually allows for only one impression per image, on a more absorbent paper, while four or six impressions, on coated stock, are possible in the more gentle offset process (leading to duotone, tritone, and quadratone processes). The pictures will look very different if they are printed by different means, gravure having a blacker, less precise feel than offset. And in my experience, they will affect the viewer differently.

Pictures in a book allow the reader to scan them more closely, for example to compare actual facades of houses of worship and images of facades, to come back again and again with no one watching (as there might be someone watching on the street). If the photographs are actual silver gelatin prints and they are large enough, then the reader (now more a photo interpreter for an intelligence agency) might discover new detail, detail unavailable in a printed book with even a fine halftone screen. For when you get closer to a mechanically printed image (say using a ten-times magnifier), you will see the halftone screen rather than the fine detail or eventually the graininess in the original photograph. Much the same is the case for digitally printed photographs (when using inkjet-type printers or even web-offset digital using Hewlett-Packard Indigo printers).

28. S. Plattner, *Roy Stryker USA, 1943–1950* (Austin: University of Texas Press, 1983), 16–17.

29. Here I am thinking of Aby Warburg (see E. H. Gombrich, *Aby Warburg*

[Chicago: University of Chicago Press, 1986]; and Steinberg, *Sexuality of Christ*, on interpretation).

Chapter 6

1. Krieger and Holman, "A Dozen 'Tamales!,'" 228–30; audio supplement at http://jpe.sagepub.com/content/vol27/issue2/images/data/228/DC1/T44. mp3 has the recording. The recording is also available on the DVD accompanying T. Holman, *Sound for Film and Television*, 3rd ed. (Burlington, Mass.: Focal Press, 2010), which has as well my recordings of a Beverly Hills restaurant and of the Farmers Market in Los Angeles, these latter two in surround sound.

2. See de Thézy, *Marville Paris*; P. Barberie, "Conventional Pictures: Charles Marville in the Bois de Boulogne" (Ph.D. diss., Princeton University, 2007); and P. Barberie, "Charles Marville's Seriality," in J. Smith, ed., *More than One: Photographs in Sequence* (New Haven, Conn.: Yale University Press, 2008), 31–45.

3. R. M. Schafer, *The Tuning of the World* (New York: Knopf, 1977), reissued as *The Soundscape: Our Sonic Environment and the Tuning of the World* (Rochester, Vt.: Destiny Books, 1994).

Chapter 7

1. The topologists of the nineteenth and twentieth centuries created a discipline based on these observations, and, for example, they connect the number of faces, edges, and vertices—information locally available by walking around on the surface—of an (irregular-)polygon-faced object in terms of the number of holes in it. (The mathematician's restrictive assumptions give them a power we cannot have in our everyday unrestricted world.) The philosophical tradition of phenomenology, concerned with knowing a whole in terms of its aspects (and these might be multisensory), developed at the same time. Rather than the mathematicians' restrictive assumptions, here we start out with a suspected notion of the whole, and that notion is modified or discarded to be replaced with another tentative notion.

2. There are computer programs to do this in terms of synthesizing a larger scene from smaller parts that are stitched together, but I am speaking of complex places such as a home with many rooms and windows where adding up pieces will not work, until you know what they will add up to. Again, you had better have a rough idea of what a house is like before you begin.

Index

Acknowledgments

For a professor of urban planning at a university located in the middle of Los Angeles and Southern California, what I see going to work, what is right around me, is the stuff of an academic career. The University of Southern California has proved to be a good place to pursue my varied projects and books, to bring up my son, and to be of service to an institution. For the latter, I want to thank our provosts, and especially Vice Provost Marty Levine. I am grateful for the enduring support of my deans, and for the financial support of the Office of the Provost of the University of Southern California for an Advancing Scholarship in the Humanities and Social Sciences grant. I have also received substantial support through grants from the Integrated Media Systems Center at USC, the John Randolph Haynes and Dora Haynes Foundation, the University of Southern California–California State University at Long Beach METRANS Project, and Google Research.

Many years ago, at Columbia University, I learned from Paul Byers that photography could be an effective means for studying society, space, and social interaction. Eric Livingston and Gian-Carlo Rota have deeply influenced my thinking about choreography and phenomenology. Genie Birch has supported this book at just the right time in just the right way.

Professor Dominick Miretti gave me access to the Ports of Los Angeles and Long Beach in his role as a member of Local 63 of the ILWU. Luis Cortés introduced me to "locate and mark" for utilities. Chuck Street gave me the opportunity to gain aerial views of Los Angeles. Frank Toscano guided me through the now-old Los Angeles County–University of Southern California General Hospital Building.

I appreciate the continuing encouragement of my colleagues at the School of Policy, Planning, and Development at the University of

Southern California, and especially the kindness of our staff. My once colleague Greg Hise has been a wonderful collaborator and friend. My more recent collaborators, Tom Holman, Ramesh Govindan, Moo-Ryong Ra, and Jeongyeup Paek, made it possible for me to explore urban tomography in new media and realms. My undergraduate research assistants, Eduardo Arenas, Natalie Golnazarians, Jack Lam, Kazuma Kazeyama, and Junhan Tan, converted ideas into actual projects and archives. Dace Taube, of USC's Regional History Collection, has facilitated my setting up an archive of the work.

It is worth reiterating that Haynes Foundation support has been crucial to my documentation projects.

My son, David, teaches me again and again that there are lots of questions to be asked about what is apparently obvious in the everyday world.